HAVERFORDWEST

THROUGH TIME

Patricia Swales Barker

AMBERLEY PUBLISHING

Acknowledgements

Many of the older photographs were taken or collected by my father or me. I am grateful to John and Brenda Munt, Stuart Mills, Heidi Lewis, Andrew Cromwell, David Redd and Tony Morris for their willingness to allow me to use some of their collections and to Mrs Jean Whiting for permission to include some of the wonderful photographs taken by her father, Mr Harold Price. I am also grateful to my late husband Alan who invested in an excellent camera and equipment, which I have used to take the contemporary photographs.

First published 2013

Amberley Publishing
The Hill, Stroud
Gloucestershire, GL5 4EP

www.amberley-books.com

Copyright © Patricia Swales Barker, 2013

The right of Patricia Swales Barker
to be identified as the Author of this work
has been asserted in accordance with the
Copyrights, Designs and Patents Act 1988.

ISBN 978 1 4456 1614 8 (PRINT)
ISBN 978 1 4456 1629 2 (EBOOK)

British Library Cataloguing in Publication Data.
A catalogue record for this book is available from the British Library.

Typeset in 9.5pt on 12pt Celeste.
Typesetting by Amberley Publishing.
Printed in the UK.

Introduction

Although the exact date of its establishment is unknown, Haverfordwest recently celebrated 900 years of existence. The castle was at the centre of the early settlement, which was located at the lowest crossing of the western branch of the River Cleddau.

Within a hundred years or so the town was established, with three parishes and a priory. In 1169 a charter granted privileges to inhabitants, including the freedom of the town for anyone living there, unchallenged, for a year and a day. In 1220 Llewellyn the Great attacked the town, which burnt as far as the castle gate, but rebuilding must have started immediately as by the start of the fourteenth century the town had become one of the largest in Wales. Its centre was the area around St Mary's church, where a Guildhall was built and a market established. The wealth and confidence of the town at that time is reflected in the fine quality of construction of the church dedicated to St Mary the Virgin.

A Royal Charter in 1479 decreed that the town should be governed by a Common Council consisting of the mayor (who was also Admiral of the Port), sheriff, two bailiffs and twenty-four burgesses or freemen. Craft guilds were established; their members protected their financial interests.

The town's central location in the county was vital to its growth, and it became the county town of Pembrokeshire in 1536. Shortly afterwards it gained the status of a county in its own right, with the privilege of holding its own assizes and returning its own member of parliament.

Due to its loyalty and services to the Crown in the Middle Ages, the town was granted several charters regarding exclusivity of trade, with the right to hold fairs and markets. In the Elizabethan period the town's market was reported to be one of the best in Wales. Over several centuries it was held in and around St Mary's churchyard and in the

shambles around the Guildhall, situated where the South African war memorial now stands.

In 1695 the town was granted the right to hold three fairs annually. The October Fair was held on Portfield common land, and retained the name 'Portfield Fair' when it moved to St Thomas Green in 1838. It remained there until a few years ago.

Haverfordwest thrived as a port as it could accommodate vessels up to 200 tons. From 1609 the mayor, as Admiral of the Port, had jurisdiction over the length of the river area from White Stone at Boulston to the quay. The annual ceremony of 'Beating the Bounds' survives. Industries grew up along the riverbank from North Gate to the old quay. Warehouses were built for the wide variety of goods passing through the port and a large percentage of the population was employed in occupations associated with the maritime industry.

Haverfordwest became an important trading centre as, alongside the markets and fairs, shops selling a wide range of goods flourished. By the eighteenth century much of the town's trade was in the hands of merchants as they acted as middlemen between craftsman and customer. Most of the town's shops were to be found in Bridge Street, Quay Street and Shoemaker's (Market) Street. In 1827 a modern Market Hall was built in Market Street and from the mid-nineteenth century the shopping centre expanded into High Street, where the houses of the gentry and upper classes were bought and converted into shop premises by aspiring merchants and tradesmen.

From the beginning of the eighteenth century many of the principal county families had set up their town houses in Haverfordwest, settling in impressive properties in High Street, Hill Street or Goat Street. They met socially at the Assembly Rooms in St Mary's Street, the Race Course, and Potter's Institute and Library. They played bowls on Castle Green, enjoyed walking on the Parade and would have attended one of the town's places of worship. In 1791 the town was called 'Little Bath'. Their spending power and influence greatly benefited the town.

Following the 1835 Municipal Reform Act, Haverfordwest became a borough governed by a mayor and sixteen councillors. This was to herald a new era in the history of the town as the council, private entrepreneurs and the Sir John Perrot Trust worked to advance many improvements to the infrastructure of the town. Between 1830 and 1850 the area from Salutation Square to the top of High Street underwent huge redevelopment. The New Bridge provided a much more convenient and imposing entrance into the town. At the top of High Street the Guildhall, location of Assize and Great Sessions courts, was demolished and a prestigious new Shire Hall was built at the bottom of the street.

The railway arrived in Haverfordwest in December 1853, transforming the import and export of goods from the town and its surrounding area. It provided a vital transport link to the main towns of South Wales and further towards London and other major English cities. The growth of the railway, however, seriously affected the port trade, which reduced dramatically, having financial consequences for the town's administrators and the industries linked to the river and sea trades.

During the nineteenth century the shopping centre of the town greatly expanded. By 1900 almost every building in High Street, Market Street, Dew Street and Bridge Street accommodated a shop or inn. Several national stores moved into town. In addition, small general stores were to be found in most of the other streets and squares. For most of the twentieth century Haverfordwest was a thriving market town with a vibrant shopping centre, attracting customers from the county and beyond. Its biggest problem was road traffic as the streets of the old town tried to cope with the increased number of cars and delivery vehicles and the demand for parking space by shoppers and workers.

In 1982 Preseli District Council built a new market on the riverside behind Bridge Street, intending that this would consolidate and generate trade in the lower part of the town. This decision marked the beginning of a transformation of the town's traditional shopping centre. Several properties in Bridge Street were demolished and new, smaller retail units were created. In 1988 the council sold a large area of land on the other side of the river to a development company that created the Riverside shopping centre. A multi-storey car park and bus station were built adjacent to the new arcade. More recently several large national stores have established themselves in retail parks on the Fishguard Road.

The later twentieth century saw several major road developments that changed the face of the town. In 1975 the southern bypass named Freemens Way opened, stretching from Salutation Square to Merlin's Bridge. It was designed to divert much of the traffic from the centre of town, but the construction of roundabouts at both ends of the new road caused the demolition of many properties, particularly in the Cartlett area. In 1988, following the removal of many shops and business premises, a four-lane highway was constructed at Cartlett Road. A very large roundabout at Bridgend Square linked it to the new Prendergast relief road (Sidney Rees Way). North Gate was also linked to this roundabout, by means of a new road over the river. In 1989 the go-ahead was given for an eastern bypass, which connected the Narberth Road with the Fishguard Road. Finally, Thomas Parry Way was built to link North Gate and St David's Road.

The construction of a massive County Hall on the eastern bank of the river in 1999 has transformed another stretch of the riverside, although a pleasant riverside walk has been created alongside the Picton Playing Field.

In recent years, the Haverfordwest Townscape Initiative, intended to regenerate the heart of the town, has refurbished historic properties in the town centre, focusing on High Street and Market Street.

The town's medieval heritage exists not just in the castle, priory and churches but also in the topography of the town centre. Although the earliest photographs taken in Haverfordwest date from the 1860s, the camera really came into its own in the late nineteenth and early twentieth centuries, recording locations and events for posterity. These photographs are readily available in a number of publications and in Pembrokeshire County Council's Virtual Museum.

The greatest physical changes in the town centre over the last 150 years have taken place since 1980. Hopefully many of the photographs included in this publication will record many of these changes and revive memories for those who have lived through them.

It has not been an easy task to recreate the exact positions and angles of the original photographs. We are currently going through a long period of severe recession, resulting in major changes in retailing and commerce, the mainstay of the town centre. Many properties are marked with sale signs and scaffolding is constant as old properties consistently require maintenance. Unsurprisingly motor vehicles have provided the greatest challenge! The constraints of health and safety and self-preservation mean that some of the photographs have been taken from a slightly different angle from the originals. In many cases I have included extra width to provide a better context.

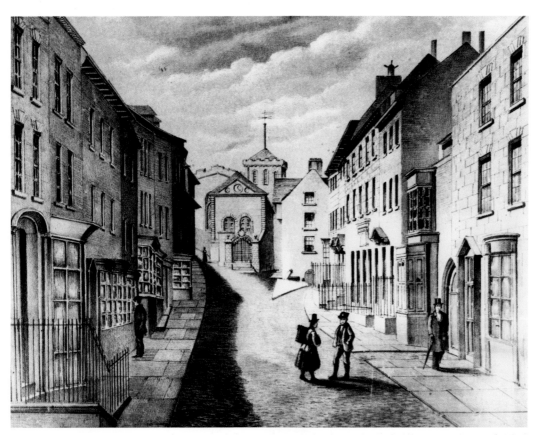

High Street, 1823

This print by local schoolmaster Thomas Ellis illustrates the upper part of High Street, which at that time was occupied by several members of the nobility, clergy and professions. During the nineteenth century, as residences went on the market they were bought by traders such as drapers, saddlers and bootmakers who set up shop, housing their families, apprentices and assistants in the floors above. Just below St Mary's church at the top of the hill is the old Guildhall, demolished in 1835 and replaced by a new Shire Hall, built at the lower end of High Street. In 1904 the South African war memorial was built in the area vacated by the Guildhall.

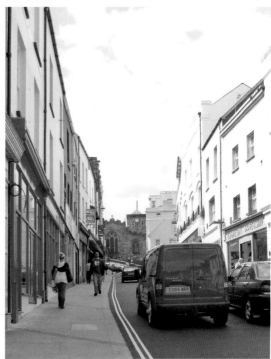

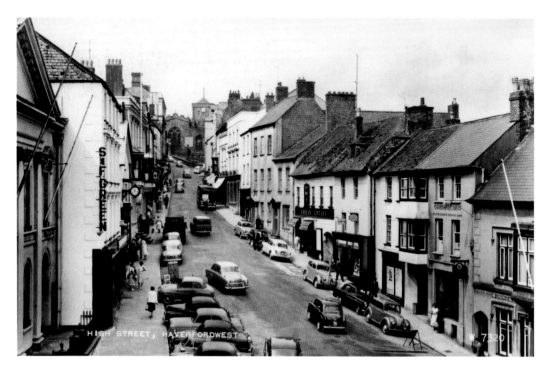

High Street with St Mary's Church in the Background

The general view of the street, a steep rise with St Mary's church at the top, remains much the same as it was when this photograph was taken in the late 1950s. At that time the firm of S. & F. Green, ironmongers, was celebrating over a century in their premises next to the Shire Hall. They had expanded by locating their cycle shop opposite, marked by the HMV sign as they also sold gramophones and 78 records. The High Street of the time was the lively and energetic hub of the town's shopping centre.

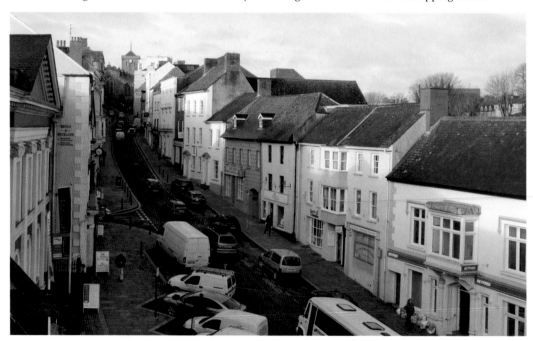

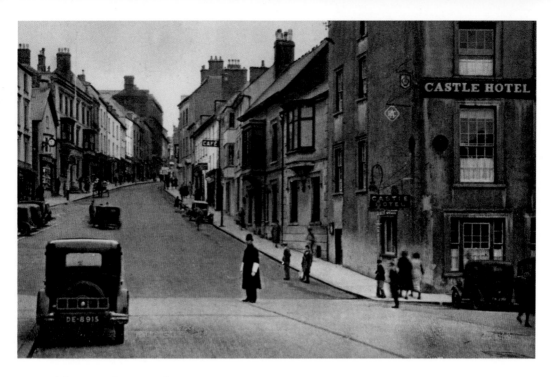

High Street from Castle Square

Until the 1830s, within this wide area at the bottom of High Street there were two very narrow and busy streets, Back and Front Short Row. They were demolished as part of William Owen's grand design for this part of the town. The traffic policeman has long since been replaced by traffic-light control, the roadway significantly narrowed and pavements widened in an attempt to give precedence to the pedestrian. Until around 1960 the parking area outside the Shire Hall was delineated by a cobbled area, the last vestiges of a street laid out in the age of the carriage and coach.

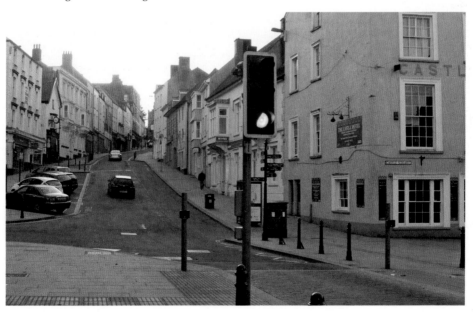

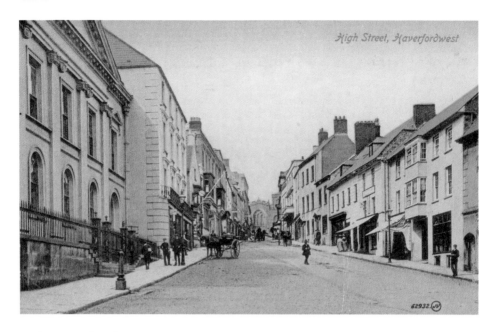

High Street, the Shire Hall

The Shire Hall, built in 1835, was designed by William Owen, local architect and innovator of the regeneration of the town, as the new venue for the courts, public meetings and entertainments of many kinds. For almost 170 years the building was the centre of local justice, but security concerns and the perception that modern requirements were lacking forced the relocation of the courts in 2003 to a new home in Hawthorn Rise. Following this, the future of the Shire Hall has been the subject of controversial debate, and although the old Magistrates' Court has been transformed into a restaurant, the future of the historic Crown Court Chamber (scene of many notable trials including those of the alleged Rebecca rioters), has yet to be settled.

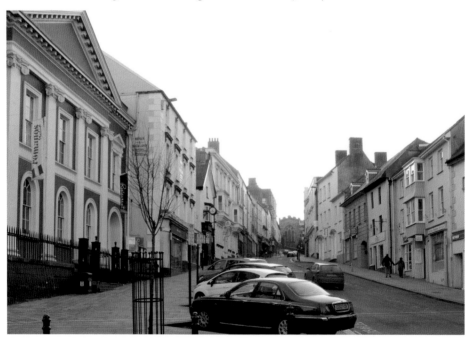

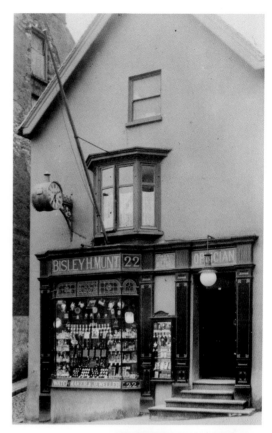

High Street, Bisley H. Munt Shop

Located on the junction of Hill Lane and High Street and probably established even before the date of 1796 painted above the doorway, Munt's jeweller and watchmaker is the oldest surviving shop in town. Remarkably the seventh generation of the family is now involved in the business. It was started by James Bevans. After his death, his wife continued to run it. In 1879 the management of the business was taken over by Bisley Henry Munt of Buckingham, who married James's daughter Martha. The clock, a landmark in the town, was placed there in the 1880s. High Street properties were renumbered in the early years of the twentieth century.

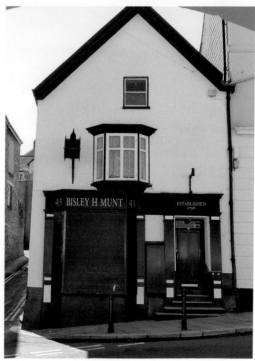

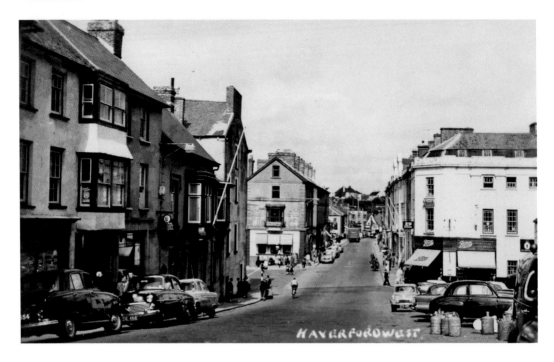

High Street and Victoria Place

Two-way traffic is light in the earlier photograph. On the immediate left, marked by the flagpole, is the County Club, which opened opposite the Shire Hall in 1878, providing a meeting place for professionals, the judiciary and the county's landed classes. It closed in 1989 and currently houses a betting shop. On the right of the earlier picture is the large building occupied from by Boots the chemist, pharmacy and lending library. Boots moved to the Bridge Street premises vacated by Woolworths in the late 1950s. W. C. John, men's outfitters, occupied the property until recently.

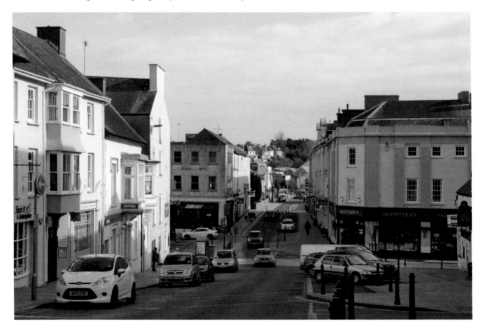

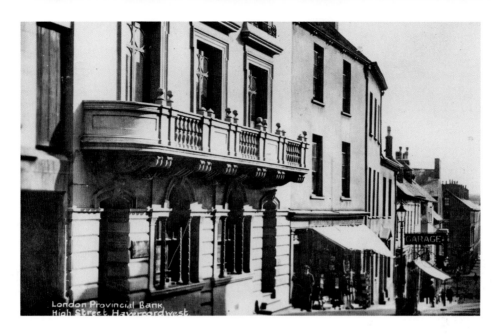

High Street, London & Provincial Bank

Sadly the elegant balcony which graced the London & Provincial Bank on the north side of High Street has long gone and the frontage is now more functional, with necessary security features and an ATM machine. The manager would have lived above the bank, which had a smart banking hall, wooden counters and personal service. The London & Provincial Bank, which absorbed the Pembrokeshire Bank in 1873, later became part of Barclays Bank. Although many shops have now left the High Street, the banks have remained. For many years the shop next door to the bank was an ironmonger's, but it is now one of the many charity shops in the town.

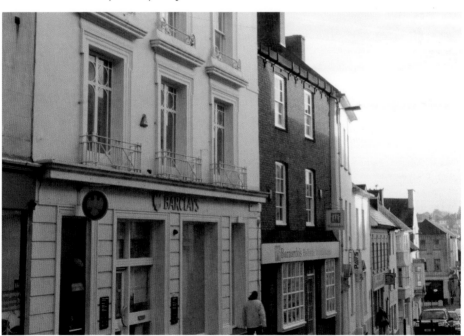

13

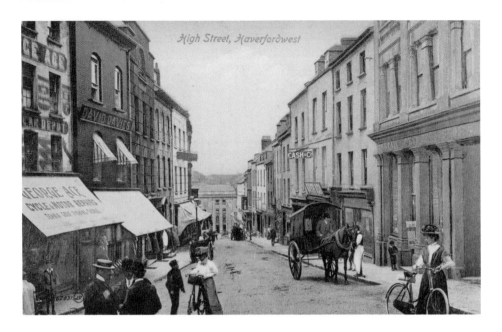

High Street

Below Rees Brothers' grocer's, marked by its sign, was Cash & Co., one of the first national stores to reach the town, selling ready-made boots and shoes. On the left of the early twentieth-century picture, with an advertising awning shading the window, is the cycle and motor repair shop of George Ace, who expanded his business from its base in Tenby, opening this shop in around 1905. Sales of cycles, golf clubs and fishing accessories reflected the growing interest in recreational and sporting activities. Next door stood David Davies, tailor and outfitter, who owned the Ready Money Clothing Warehouse. In the contemporary picture scaffolding, seemingly ever-present in the town these days, obscures the view of the north side of the street.

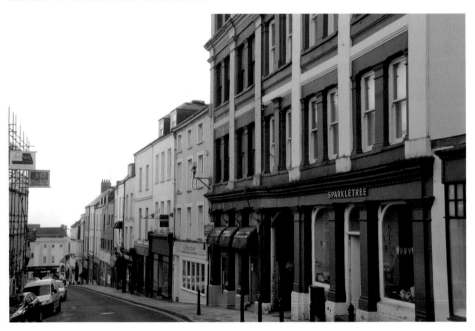

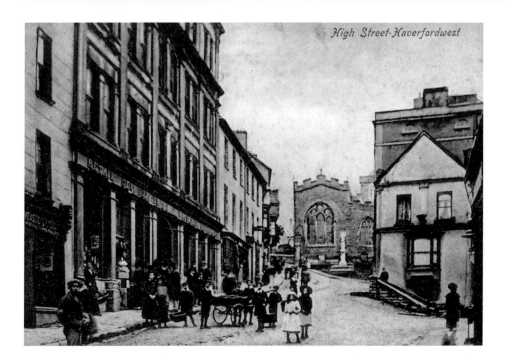

High Street

A very large commercial property dominates this early photograph. In 1871, on the site of the renowned Potter publisher's and library, P. P. Ellis built a very large grocery business, with retail and wholesale departments, claiming it was 'the largest building in the United Kingdom exclusively devoted to the grocery trade'. The sales and storage area covered 1,200 square feet on four floors, with stables and loading bays at the rear of the premises. In 1893 the shop was taken over by Rees Brothers who further improved the shopping experience, importing an American Hobart electric coffee mill, which pulverised the coffee until it was as fine as flour and poured as clearly as wine. Sidney Bowler continued the business, but more recently the buildings were occupied by the Continental Café and Blue Jeans shop.

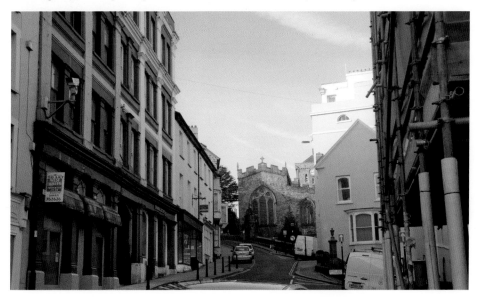

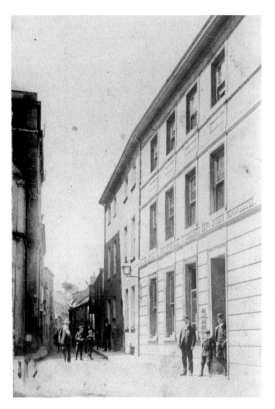

Dark Street

No longer visible is the carved inscription 'National Provincial Bank established AD 1833'. The National Provincial Bank merged into the National Westminster Bank in 1970. The premises now house the Probation Service, while the NatWest Bank can be found in a more modern building next door. Dark Street is a narrow street linking High Street with the Mariners Square, and the height of the buildings on the left side really does deprive the street of any sunlight. These properties all have entrances onto High Street and St Mary's Street, and several have medieval cellars that open onto Dark Street.

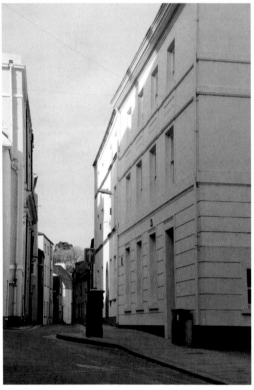

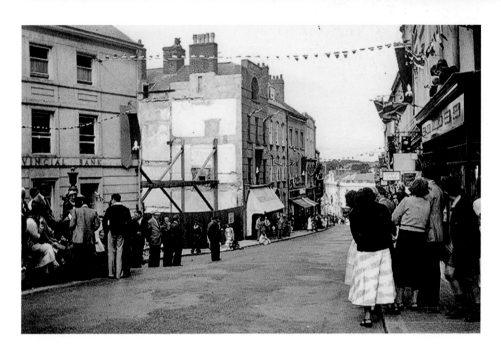

High Street Architecture

This photograph, dating from the 1950s, is particularly interesting as it records a major change in the High Street's architecture. Two large properties were demolished to make way for a building totally incompatible with the rest of the street. This was the National Westminster Bank. The William Nichol Memorial, a red-granite pillar marking the spot where the Marian Martyr was burnt at the stake in 1558, can be seen clearly in the modern photograph. The shop on the right of the picture was occupied by WHSmith for almost a century until the firm removed to the Riverside development.

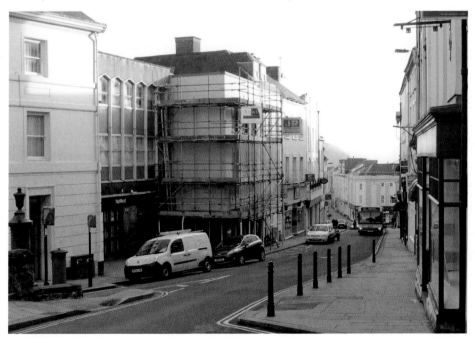

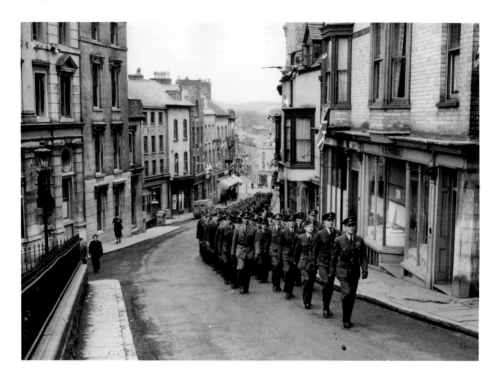

High Street, RAF Personnel

A large detachment of RAF personnel on church parade marches up High Street festooned with flags in the 1950s. On the right-hand side is the butcher's shop of W. R. Thomas. A young Grammar School pupil and a WRVS lady seem to be the only onlookers. The van probably belongs to the milkman walking past T. P. Hughes. On the right-hand side of the modern photograph one of the oldest buildings in the street can be seen just below the Chinese takeaway and hair salon.

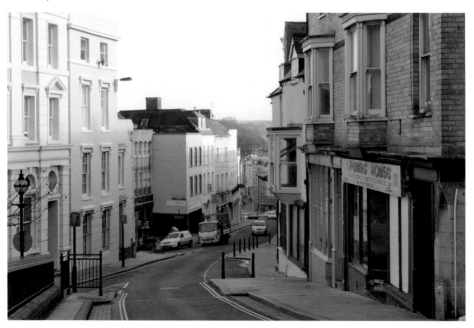

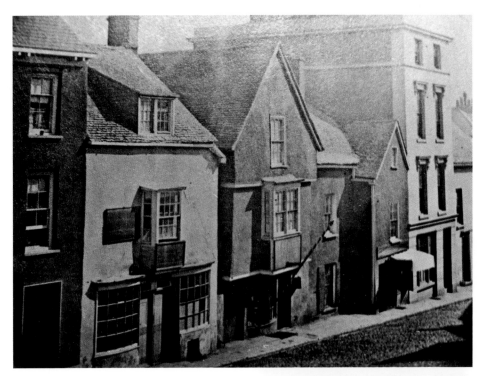

High Street

Only one out of this group of shops at the top of High Street has survived, though without its bow windows. Until 2002 this small shop was part of Swales Music Centre, but previously it housed S. D. Pugh's barber and tobacconist shop. In the 1870 photograph it is the shop next door that is marked by a barber's pole. In 1883 this shop and its lower neighbour were demolished to make way for the town's prestigious new post office. Designed by architect D. E. Thomas, this originally had three floors; a fourth was added in 1912. The house at the end of the row, named Borough House, is unique in High Street in having always been a dwelling house.

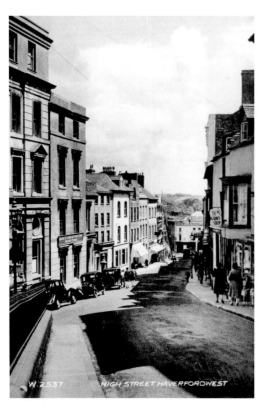

High Street, Post Office

The post office was opened at these premises in 1883. The postmaster was Thomas Baker, who had previously traded as a saddler in a shop opposite his new office. The mail sector of the post office removed to Quay Street in 1936, but this building continued to house the telephone exchange and engineers until a large new exchange was built in Perrot's Row around 1960. Following this the building was in use as the Unemployment Exchange before the County Council took possession, creating residential units on the upper floors and offices on the ground floor.

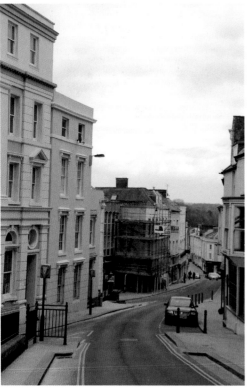

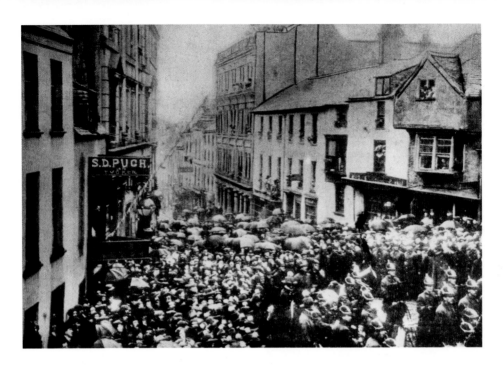

High Street, South African War Memorial

The South African war memorial was dedicated at the top of High Street in 1904 and hundreds turned out on what must have been a very rainy day. The band was from the 53rd Shropshire Regiment. The only real difference in the photographs is the removal of the Elizabethan frontage of No. 7 High Street. The barber's pole outside S. D. Pugh's men's hair salon remained until 1975 when the building became part of Swales Music Centre.

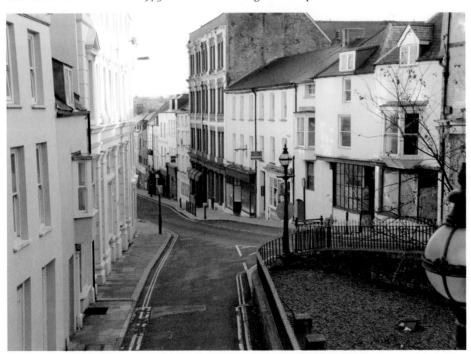

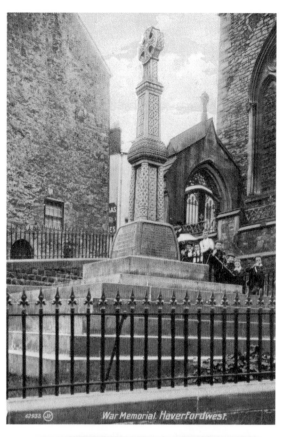

War Memorial. Haverfordwest.

High Street, South African War Memorial

The South African war memorial, recording forty-four names of Pembrokeshire soldiers who died there between 1899 and 1902, was constructed in 1904 by local monument mason, Havard. The design of a Celtic cross was retained when the decaying memorial was replaced in 1986.

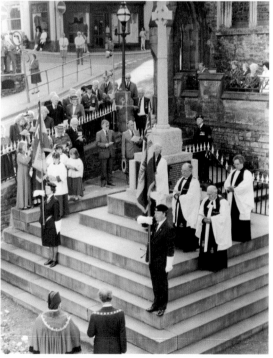

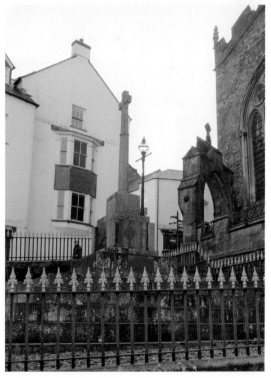

High Street, South African War Memorial

The background in the earlier photograph is the side of Westaway Corner, a building demolished in the 1950s to provide a better view for traffic turning out of Market Street. For some fifty years this allowed the public to see the Crypt, a medieval vaulted cellar. But in 2010 a tall new house, part of the Commerce House redevelopment, was built over the Crypt. The site of the Crypt can be seen clearly in this photograph from the 1960s of one of the regular lorry breakdowns at the top of High Street.

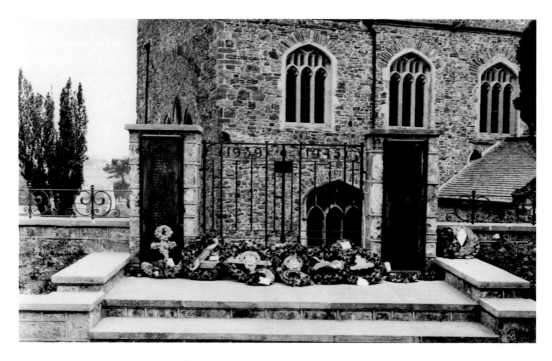

Dew Street, Second World War Memorial at St Mary's Church

Engraved bronze tablets recording the names of eighty-eight men of Haverfordwest who died in the Second World War were set into the posts of the memorial gates. The gates and railings were placed at the south-west corner of St Mary's churchyard, on the site of the old fish market. The photograph was taken when they were dedicated in 1954. In 1991 the gates and tablets were removed to a new memorial area near Salutation Square, near the First World War cenotaph, which had been moved a short distance to allow for road realignments, and this is where the second photograph was taken.

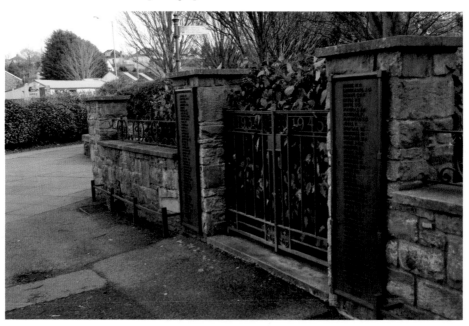

Dew Street, Grammar School
Haverfordwest Boys' Grammar School had been in existence near St Thomas' church for around 400 years before it moved to Dew Street in 1856. It remained there until 1965 when it relocated to Scarrowscant Lane, and in 1978 was merged with Tasker's Girls' Grammar School and Haverfordwest Secondary Modern School, becoming two comprehensive schools, named Tasker Milward and Sir Thomas Picton. Following the old school's demolition at the end of the 1960s, a large new County Library was built. The red-brick building on the right of the photograph is the Registry Office, behind which a swimming pool was built with money raised by public subscription. This was demolished recently. The library is now to be redeveloped, resulting in a more modern building designed for the twenty-first century, easier for access and use.

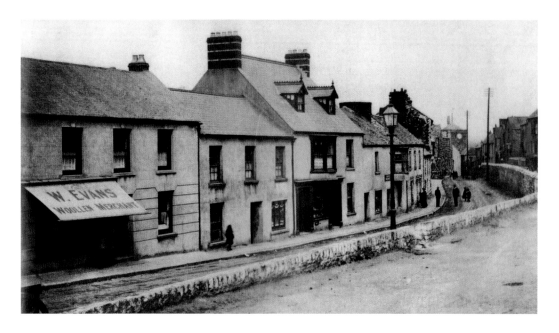

Dew Street

A hundred years ago almost all the properties in Dew Street were occupied by shopkeepers, publicans or other traders. William Evans was a woollen and flannel draper as well as a town councillor and deacon of Hill Park chapel. Now his shop is occupied by a general store. Many of the old shops are now residential properties. The Pig Bank, on the right of the picture, was the site of the monthly pig market as late as the 1930s. Dew Street probably took its name from Dewi's Well, a spring in Fountain Row, just a little further along the street, although for many years it was known as Shut Street.

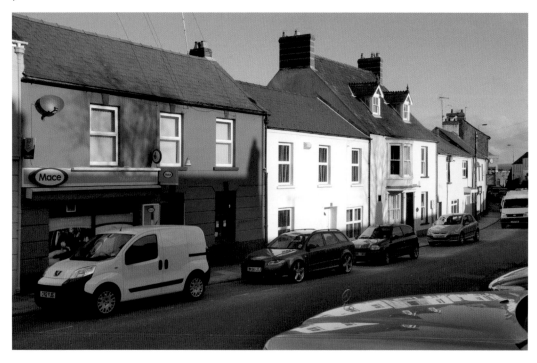

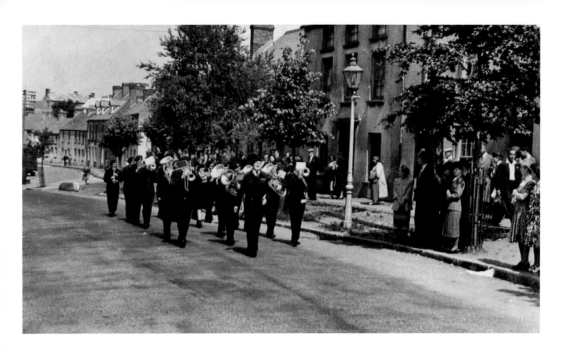

Dew Street, British Legion Band

The British Legion Band is led up Dew Street by their conductor, Joffre Swales, in around 1948. In the modern photograph the trees have disappeared, and the old County Motors premises and the parking verge produce a rather stark view in comparison. The Legion Band disbanded but during the next fifty years their conductor directed two other bands in the town, the Mary Immaculate School Band and the Haverfordwest Town & County Youth Band.

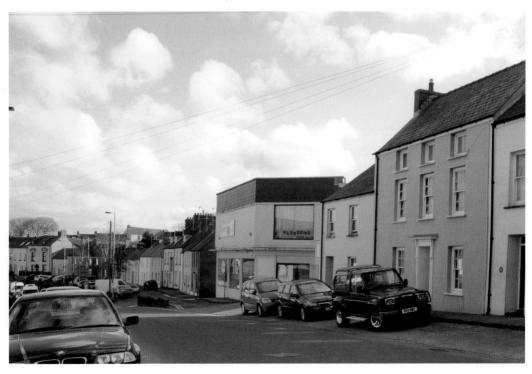

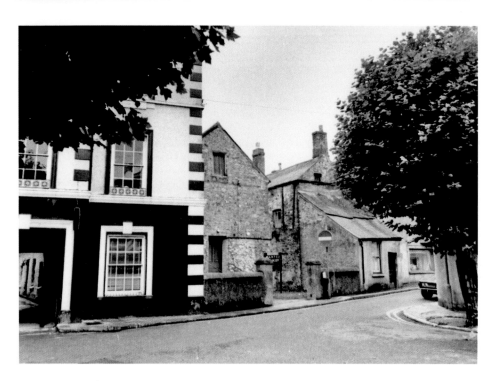

Mariners Square, the Little Theatre

Originally a malt house, the Little Theatre in Mariners Square was a much-loved venue for amateur dramatic productions until its demolition in 1974. It could accommodate an audience of about ninety people. Alongside were the old brewery house and an off-licence. The whole area is now part of Hotel Mariners. The earlier photograph shows the hotel's passageway through to the stables and other outbuildings. This has been replaced by an atrium.

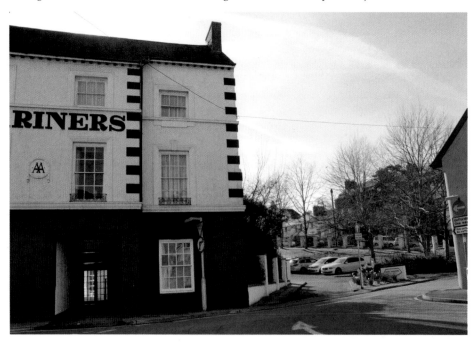

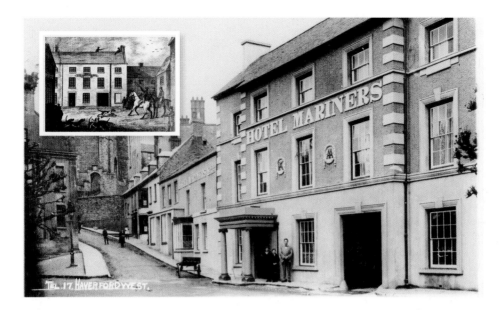

Mariners Square

Some eighty years separates these two pictures but little has changed. Although the façade of the Hotel Mariners claims it was established in 1625, the earliest record of the inn is a print dated 1729. The hotel continues to provide welcome to visitors and the local community, and is the meeting place of many organisations. Dominating the area is the tower of St Mary's church, which houses the town clock, placed there by the Sir John Perrot Trust in 1887 and which is still maintained by the trust. In recent years a plaque has been placed on the orange-painted property commemorating the life of Michael Headly of the Mariners Hotel. The triangle in front of this building was the site of the Pembrokeshire County Gaol.

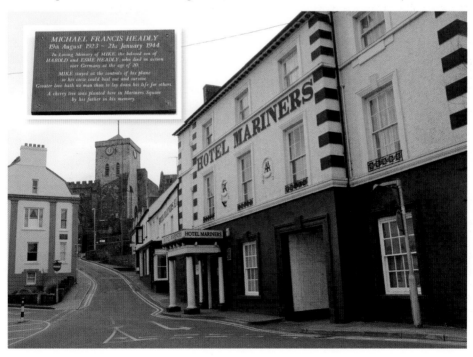

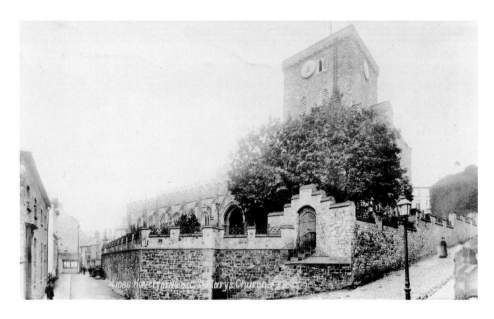

Tower Hill and St Mary's Street

The church of St Mary the Virgin has been described as one of the finest parish churches in Wales. Built around the beginning of the thirteenth century, it is particularly notable for its fine stone carvings and Tudor oak roof. The tower houses a peal of eight bells and the church organ is probably the oldest in Wales still in use. Over a century separates these pictures, but the only obvious differences are the now tarmacked streets and the addition of a door to the boiler house at the north-west corner of the church wall. In 1885 the Perrot's Trust had purchased and demolished a public house called the Old Dolphin in order to widen and improve St Mary's Street.

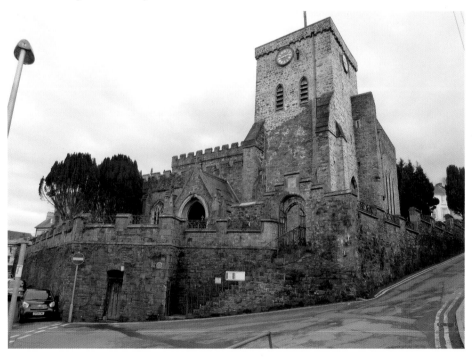

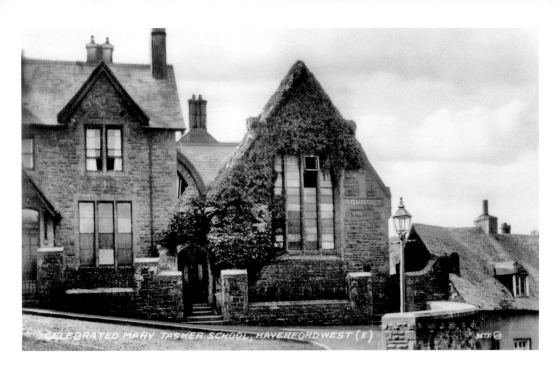

Tower Hill, Tasker's School

Mary Tasker died in 1684 and left property, the rentals of which produced a sum for the education and maintenance of poor children. In 1884 the Charity Commissioners supported the construction of a high-class girls' school for 100 pupils with a mistress's residence, to be designed by local architect Thomas Powis Reynolds. The school opened in 1892. Tasker's Grammar School for Girls moved to a new site in Portfield Avenue in 1962. In 1987 the school was absorbed into Tasker Milward and Sir Thomas Picton comprehensive schools. This building was used as a youth club and further education centre for many years before being converted into residential units.

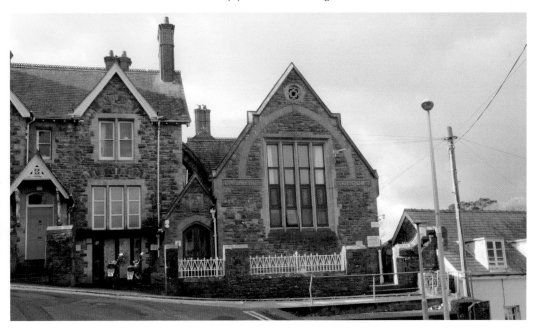

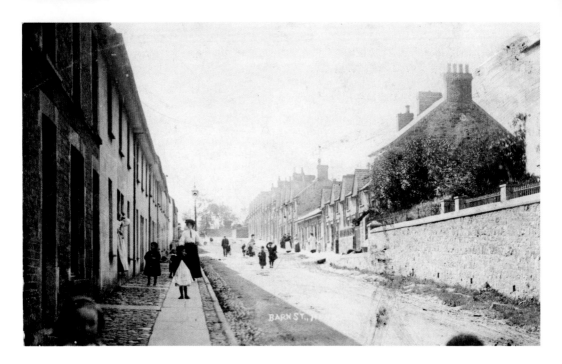

Barn Street

Sir John Perrot (1527–92) left land and property in trust for the improvement of Haverfordwest. On the north side of Barn Street is the long row of twelve Perrot houses, mostly built around 1860 and still owned by Perrot's Trust. The earlier photograph reveals that two of the houses were originally single storey. At the top of street, beyond St Mary's cemetery, is the very large Tesco superstore built in the 1990s.

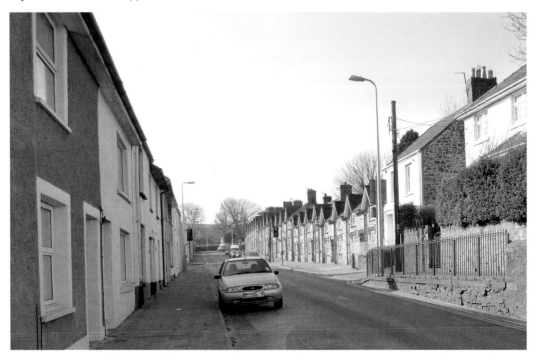

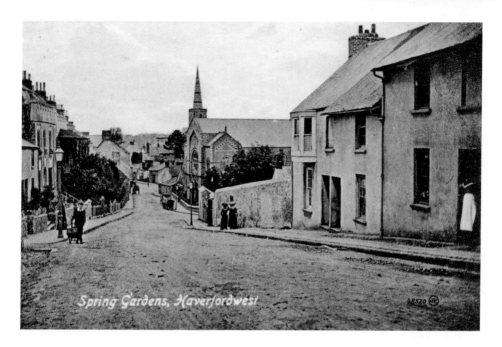

Spring Gardens

Very little has changed. Spring Gardens, located at the bottom of the Barn Street hill, includes an imposing group of Victorian town houses, two of which have a cast-iron veranda. On the opposite side of the road the long wall bounded a brewery, but the new arrangement of pillars and a large grassed area allows a view of the Mariners Hotel. The houses on the right side were known as Kensington Gardens, though this name has recently been used for a new housing development behind Spring Gardens.

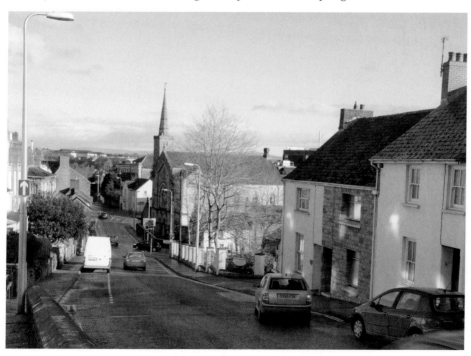

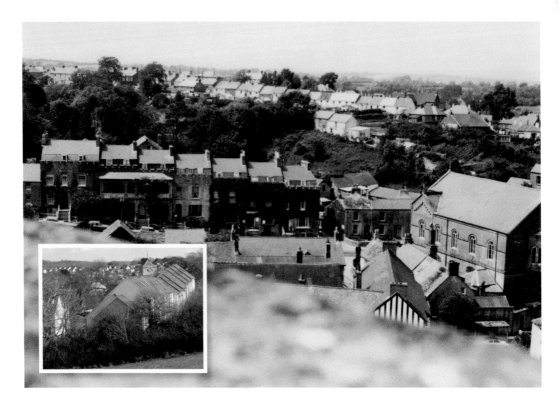

Spring Gardens from the Tower of St Mary's Church

About forty years separate these photographs, but the main change in this area is not obvious. A development of some sixty four-floor town houses now exists between the back of Spring Gardens and City Road, the row of houses along the top of the view. The high red-brick chimneys belong to the old Tasker's School on Tower Hill. The black-and-white gable end of Hotel Mariners and the Bethesda chapel are unmistakeable.

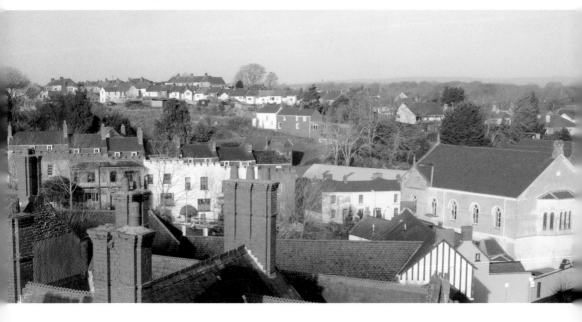

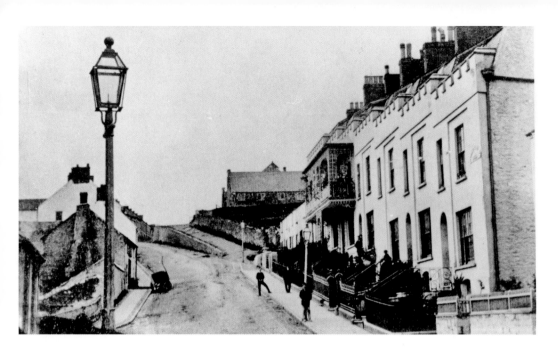

Lower Barn Street

One of the lower houses in Spring Gardens became the Pembroke House Hotel, renowned for its cuisine in the 1970s and '80s. In the earlier photograph the building at the top of the street is Barn Street VC School, a church school established in 1846. The view of the school has now been masked by a large house, which has been St Martin's Vicarage since 1927, and a row of six white houses built in 2011.

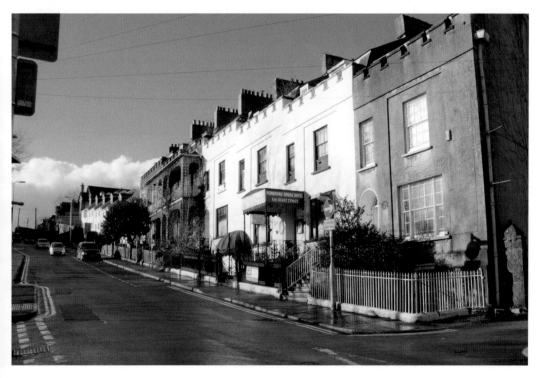

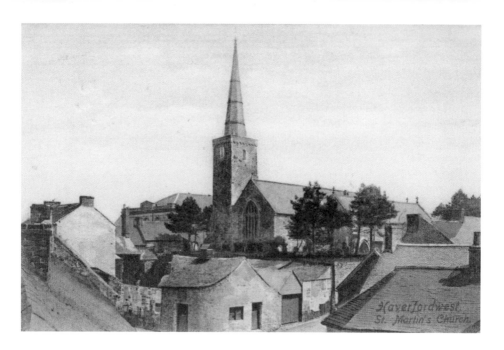

St Martin's Church

Acknowledged as the oldest of the three parish churches in the town, St Martin's was extensively restored in 1865. Its original spire was 15 feet shorter than the replacement, which was built in 1870 and remains a landmark of the town. The workshops at Cromwell Corner have been totally rebuilt. The now disused Wesleyan chapel can be seen just to the left of the church. In the later photograph the large structure on the right is the telephone exchange, built in Perrot's Row in the 1960s on the site of almshouses and the Wesleyan manse.

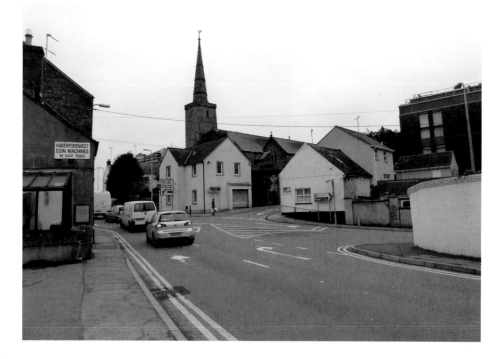

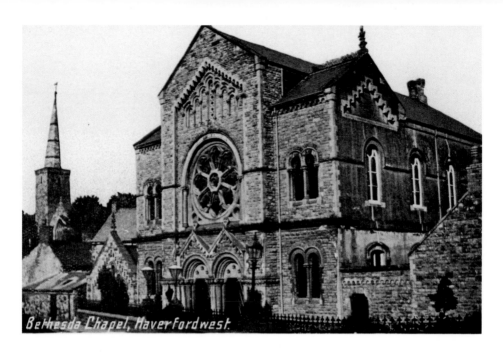

Bethesda Chapel

Bethesda Baptist chapel is one of four places of worship located at the bottom of Barn Street. The original chapel there, dating from 1789, was rebuilt and named Bethesda in 1816. This building, with the schoolroom on the left, was built in 1880. The very large interior can accommodate up to 900. These photographs show that little has changed in the last 100 years; even the cast-iron railings have survived.

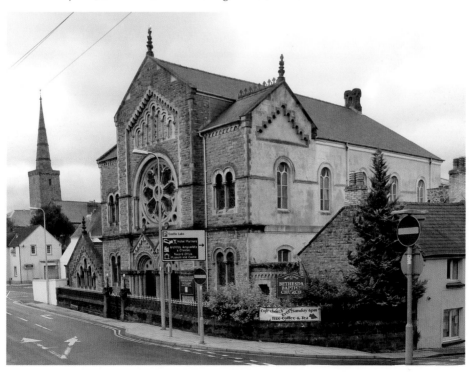

Queens Square

Queens Square is part of the Castleton area of the town and was part of a thriving community. All the properties in the earlier photograph, which probably dates from the 1950s, were demolished in the 1970s and replaced by a terrace of Georgian-style houses. Just beyond the houses is the frontage of St Martin's church hall, which has recently undergone extensive refurbishment.

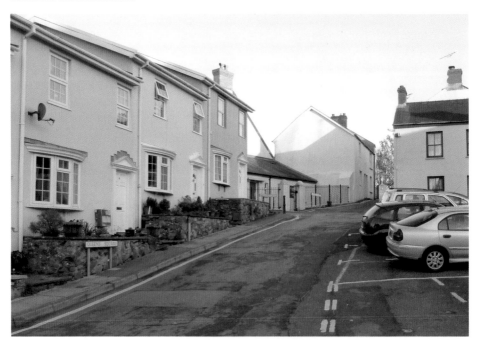

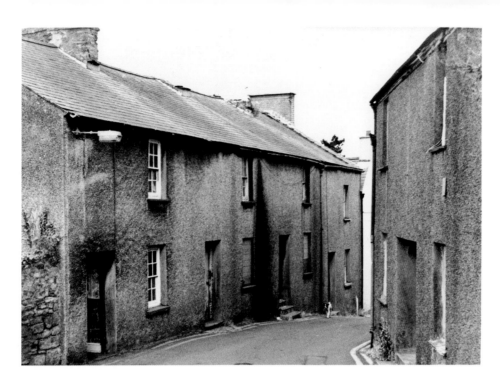

Castle Back

This narrow street provides the only vehicular access to the castle and Haverfordwest Town Museum. By the 1960s, when the earlier photograph was taken, the cottages were derelict but they have now been rebuilt.

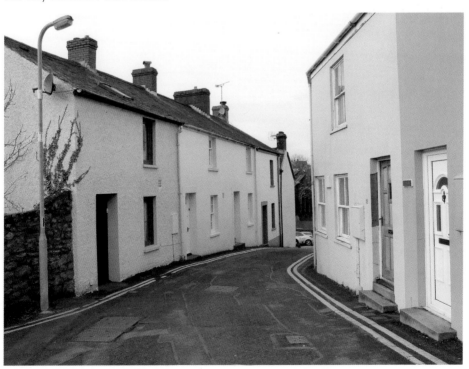

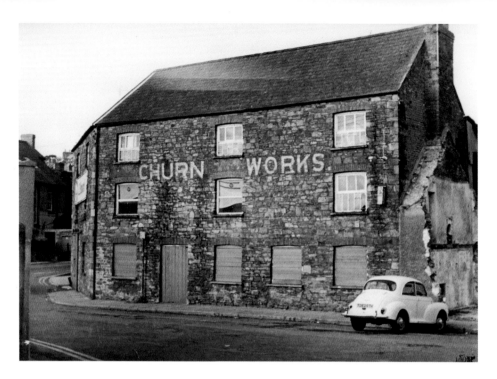

The Churn Works

Llewellin's Churn Works occupied a large site at the junction of North Gate and Perrots Road. Founded in 1789, it remained in the family for some 200 years, manufacturing a vast array of agricultural implements and machinery, employing a large workforce and supplying goods worldwide. In around 1999 the buildings were demolished to make way for this roundabout, part of a new road system in which a newly created road, Thomas Parry Way, linked this roundabout with the St Davids Road.

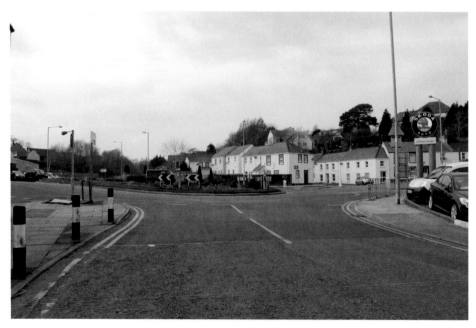

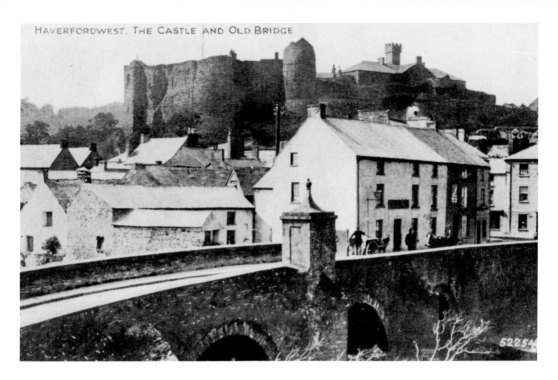

HAVERFORDWEST, THE CASTLE AND OLD BRIDGE

The Castle and Old Bridge

This group of buildings at the side of the Old Bridge has changed little over the last century. Until 1834 this was the only bridge in the town, having been rebuilt in 1726 at the expense of Sir John Philipps of Picton Castle. The buildings behind the Fishguard Arms, a long-established inn, are now part of the riverside market development. A group of tall houses built recently in Hayguard Lane, share the skyline with the castle and the County Gaol, built in 1820. The gaol's watchtower was removed many years ago.

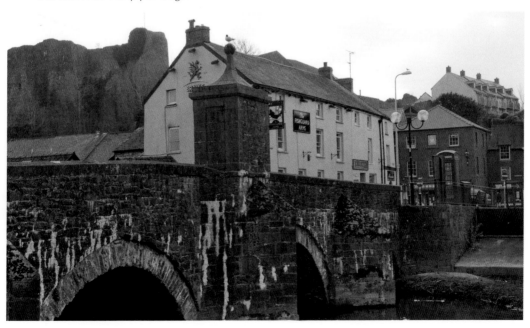

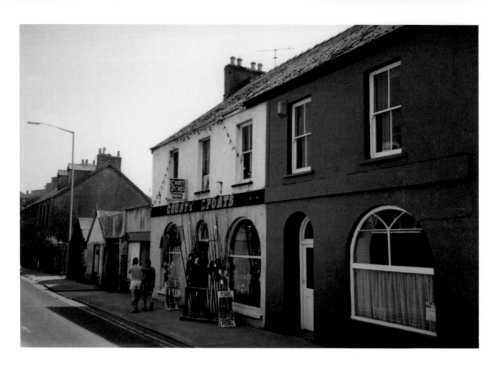

County Sports

County Sports opened on the Old Bridge in the mid-1960s, when the street was always full of traffic, particularly on mart and market days. The area was almost totally rebuilt and pedestrianised as part of the Riverside shopping development of 1990. Old Bridge Square was created adjacent to County Sports, replacing the old A. B. Griffiths' ironmonger's store and shop, and providing an entrance to the shops of the Riverside Quay. Beyond the square, a whole block was totally rebuilt and one of the properties now houses the local Tourist Information Centre.

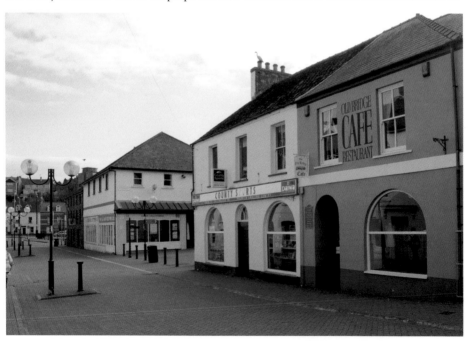

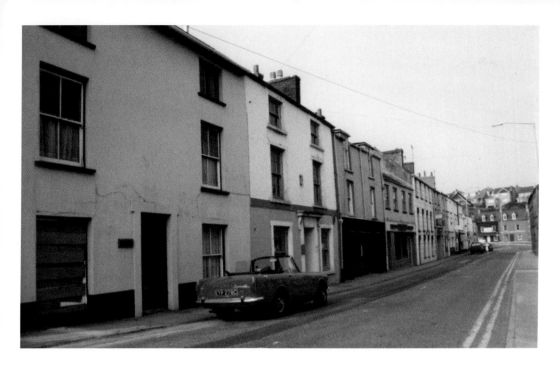

Old Bridge

A lynchpin of the 1990 redevelopment of this area was the construction of a large Leo's supermarket, which replaced the two shops and the Commercial Inn, seen in the earlier photograph, although their façades were retained. The improvements in the area extended the town's historic shopping centre and also provide a venue for the farmers' market that is held every Friday.

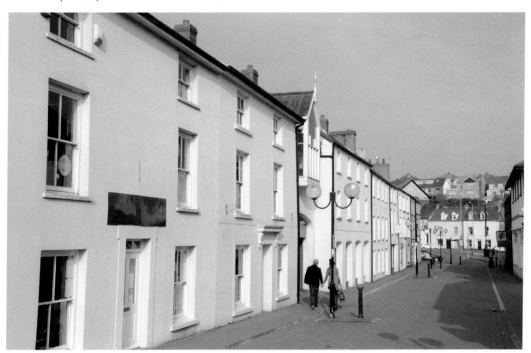

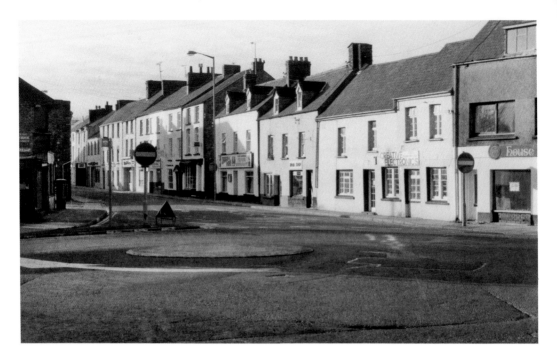

Old Bridge Road

The earlier photograph was taken in 1986, not long before the major redevelopment of the area by Preseli Dstrict Council. Between Miss Clark's sweet shop and the Dragon & Pearl Chinese restaurant was an alleyway through to the Bridge Meadow. Just visible on the left of the older picture is the tin shed from which Mr Devereux sold men's clothes. The contemporary photograph was taken early on a Sunday morning before the taxis arrived on their rank by the single-storey Dining Room.

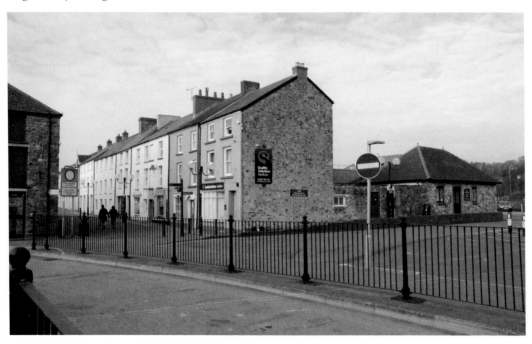

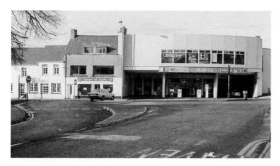

Bridgend Square

Bland's is one of the long-established firms still in business in the county town, but they had to relocate their garage from this premises at the bottom of Prendergast Hill as a part of road improvements in the later 1980s. Frequent traffic jams were caused by vehicles backing up Prendergast trying to get into the riverside car park. The newer photograph of what was Bridgend Square shows one of the pedestrian underpasses that were constructed under the Prendergast relief road (Sidney Rees Way), the large roundabout and road intersection.

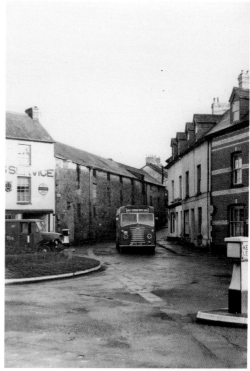

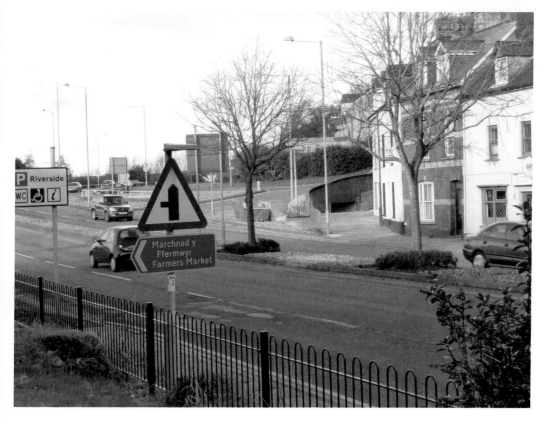

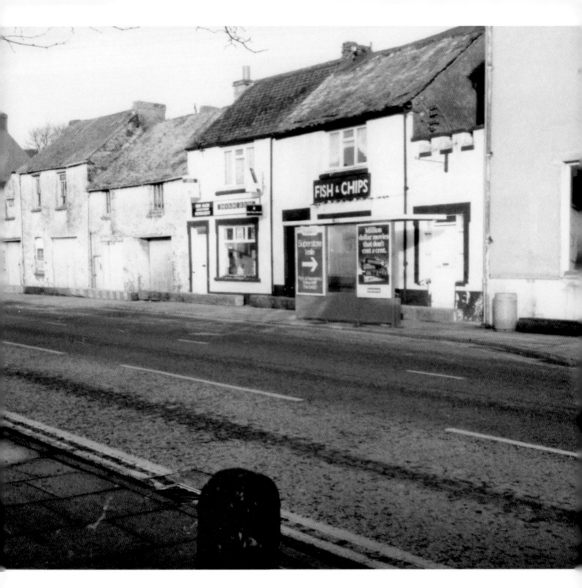

Cartlett Road

The major road development in the town in the mid-1980s involved the widening of Cartlett Road to four lanes by demolishing several shops, including the Imperial fish and chip shop, Cartlett Home & Garden Store and Brite Lites. Many inhabitants of the town despaired over what they saw as a bypass being driven through part of the town centre, and the use of thousands of pebbles to divide the carriageways. Above the wall is Prospect Place.

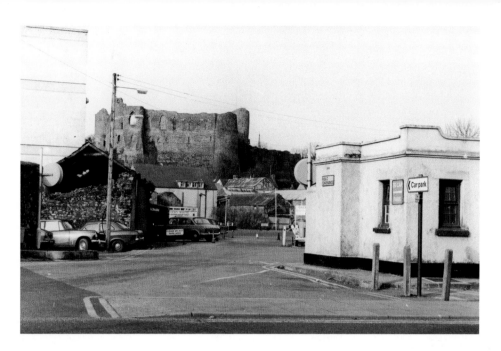

Weighbridge

The earlier photograph, taken in the 1960s, shows part of the public weighbridge office, situated on Cartlett Road, and the entrance to the Riverside car park. Now a pedestrian bridge crosses the four-lane road from near the County Hotel to Prospect Place, and steps and ramps have been provided for access. The view of the castle has been reduced by the roof of the Riverside development and the roof of the clock tower can be seen to the right of the castle.

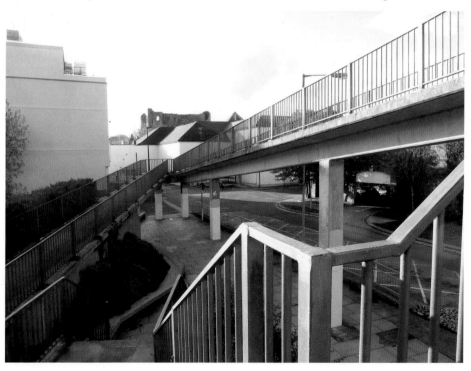

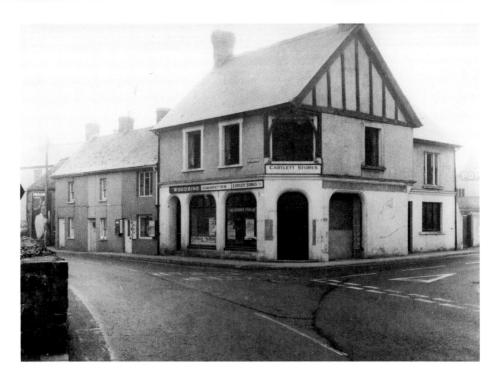

Cartlett Stores

This shop, situated at the junction of Cartlett and the New Road, was one of the many local general stores supported by the town's population before the arrival of national supermarkets. Run by the Ellis family in the 1950s, it served the Cartlett and New Road residential areas. Also in the picture is Elliott upholsterer's shop, and at the far left a small part of the Milford Arms can be seen. This group of buildings was demolished as part of the work required by the southern bypass, Freemens Way, in the mid-1970s.

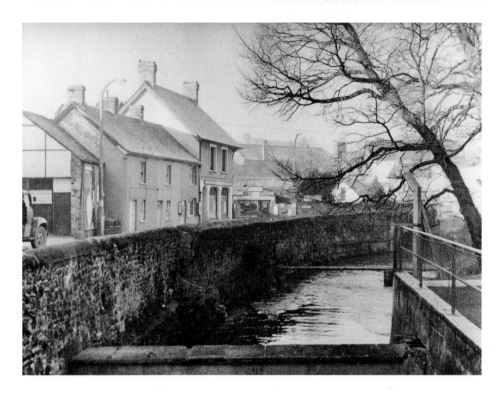

Cartlett Brook

The reverse view of the previous photograph shows the shoe repair shop of Mr Shearn attached to the row of cottages. The Cosy Corner sweet and tobacco shop can be seen in the centre of the picture. In 1975 much of the Cartlett area was altered to accommodate the new approach to the Freemens Way roundabout. Cartlett Brook is now concealed.

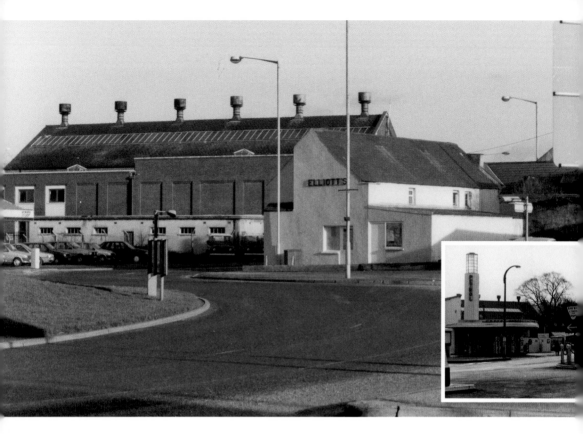

Power Station

The large power station was demolished in 1987 to allow widening of the road. Some of the site was acquired by Green's Motors to extend their garage; their petrol station had for many years been on the Salutation Square. The site of Elliot's shop was needed for the major road reconstruction so did not survive. Pope's Garage has been in place at the end of Cambrian Place for well over half a century.

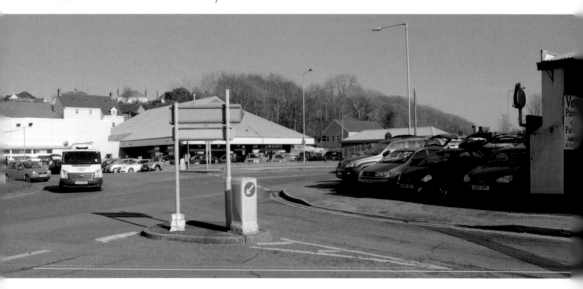

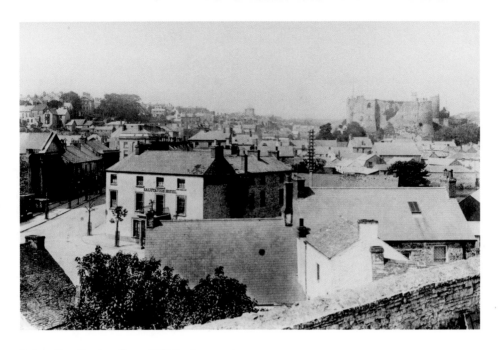

Salutation Square from Mill Bank

Central to these photographs is the Salutation Hotel, renamed the County in 1940. An impressive porch and balcony have been added at the front of the hotel. The interesting roofscape between the hotel and the castle has been obscured by the tall Iceland supermarket, although the top of St Mary's church tower can still be seen.

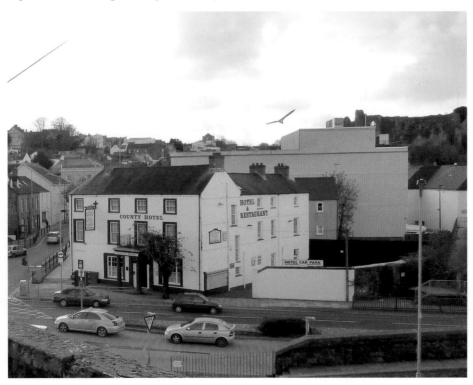

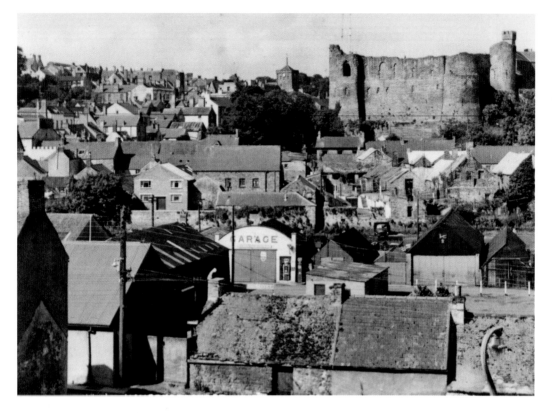

Town from Prospect Place

This view of the castle and town dates from the mid-twentieth century. Central is the Jubilee Garage, which had been built on what was a large open area known as Jubilee Gardens. Behind it can be seen the conglomeration of roofs at the rear of Bridge Street. The current view is dominated by the multi-storey car park and Riverside development.

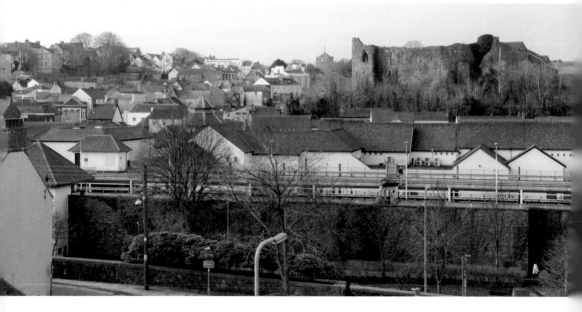

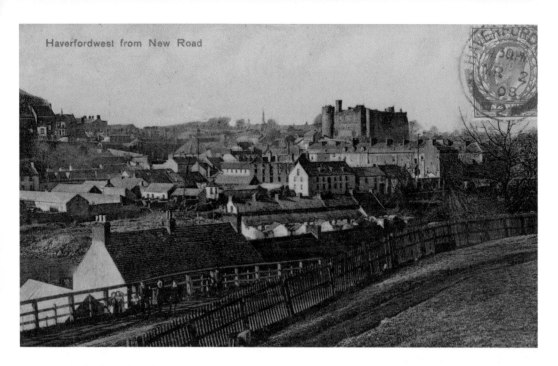
Haverfordwest from New Road

From the New Road
The New Road, which starts where Cambrian Place ends, developed as a suburb of the town from the early decades of the twentieth century. The fine view of the town, taken from just below the railway bridge and familiar to those who used the road as a promenade, has been almost totally obscured by the new County Hall building, opened in 1999. The houses in Lower Cambrian Place and the town's gasworks have long disappeared, but a large Territorial Army headquarters has been built in the area.

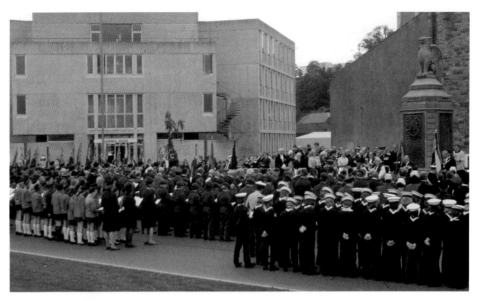

Salutation Square

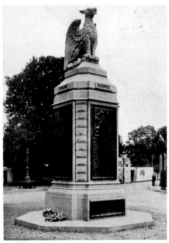

A fine group of buildings (which included Chalfont House, a doctor's surgery) between the Masonic Hall and the Mill Inn public house was demolished as part of the Freemens Way road scheme. The cenotaph, visible on the right of the picture above and in the picture to the left, was then relocated from the centre of the square to a memorial garden built at the side of the Masonic Hall. Cambria House, built in 1965 by Haverfordwest Rural District Council, became the offices of Preseli District Council when it was created in 1974. It was demolished in 2000 and replaced by the County Hall complex. The event recorded in the above photograph is the rededication of the cenotaph when it was resited in a newly created memorial garden at the side of the Masonic Hall.

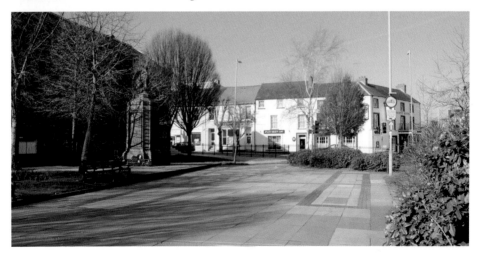

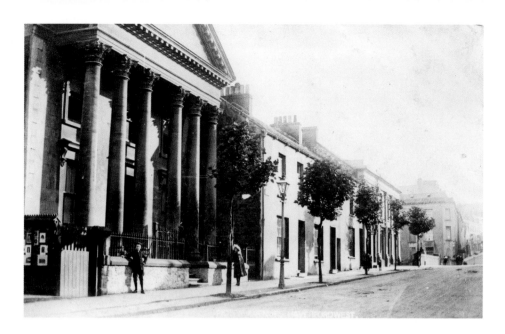

Masonic Hall and Picton Place

The Masonic Hall opened in 1872, an imposing home for the very strong Masonic tradition of the area. As well providing the Lodge with a meeting place, its large hall, which could accommodate 600 people, was designed for public events such as bazaars, banquets, lectures, concerts, public meetings, dances, and theatrical productions. For the last twenty years the hall has housed a series of nightclubs. In the older photograph, the building just before the New Bridge was occupied by the Lewis furniture warehouse, which predated the County Theatre. Now the property is part of County Hall.

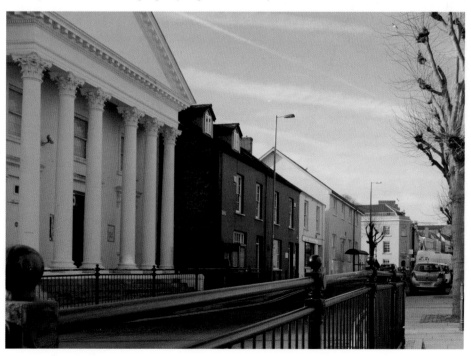

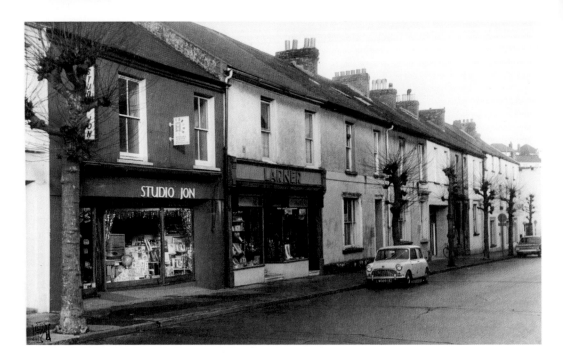

Picton Place

The 1960s photograph shows the row of properties between the Salutation Hotel and the New Bridge that were built as part of the nineteenth-century town development. Many were later converted into shops. The street was possibly named after Picton House (just off picture to the left), now the home of the Town Council. It was previously the town house of the Philipps family of Picton Castle. The concrete Iceland building was originally built for Tesco when they first came to the town in the early 1970s, replacing Larner's flower shop and some office accommodation.

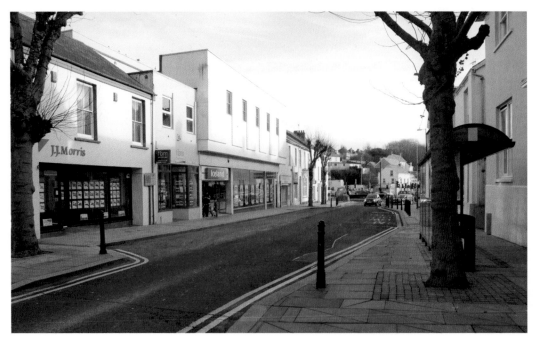

New Bridge, County Theatre
The County Theatre opened in 1935 but was demolished, to the consternation of local inhabitants, in 1980. Apart from the theatre, with full stage, orchestra pit and dressing rooms, and an auditorium capable of accommodating an audience of 1,200, a projection room and screen, the building had a restaurant, billiard hall and the Cavendish furniture shop, which can be seen in the earlier photograph. Many famous artists appeared there, although in the post-war period it was better known as a cinema. The building was replaced by a council office that now forms part of County Hall.

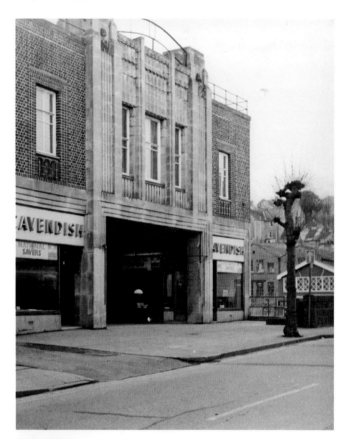

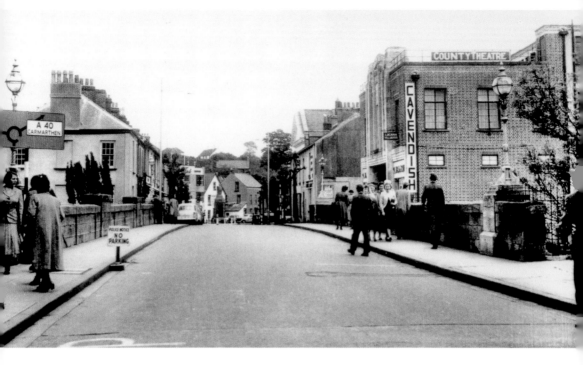

County Theatre and New Bridge from Victoria Place

The road sign provides a reminder of days before a one-way traffic system was introduced in around 1965. From its construction in 1837 the bridge has been the entrance to the town and for many years was subject to a toll. In the earlier photograph the cenotaph can be seen in the distance in its original location on Salutation Square. The contemporary photograph shows part of County Hall and the widened pedestrian-friendly pavements.

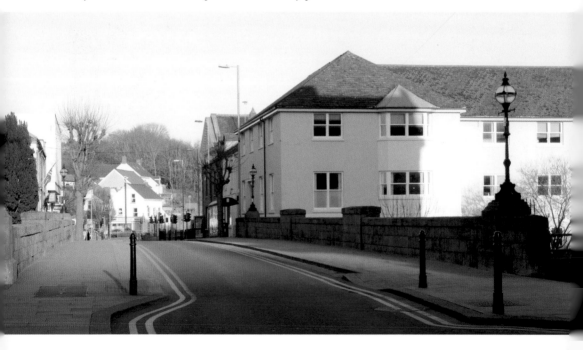

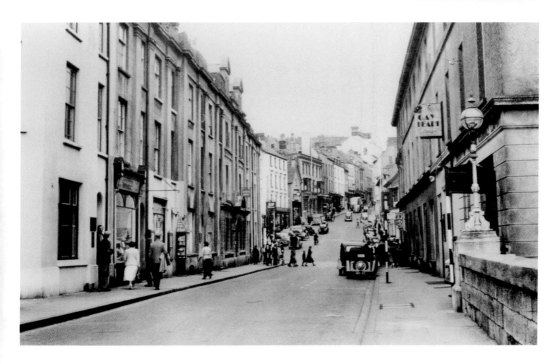

Victoria Place

Victoria Place, a terrace of town houses dating from 1837 (the year of Queen Victoria's accession), was designed by William Owen as part of the imposing entrance to the town. By the 1950s the street was the home of shops such as Mackenzie's, which sold music and toys, and the Gay Heart restaurant. The contemporary photograph shows that estate agents, building societies and a bank now occupy the street.

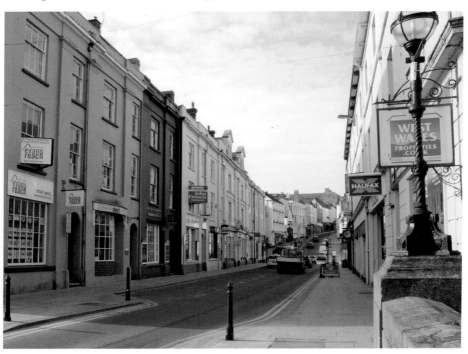

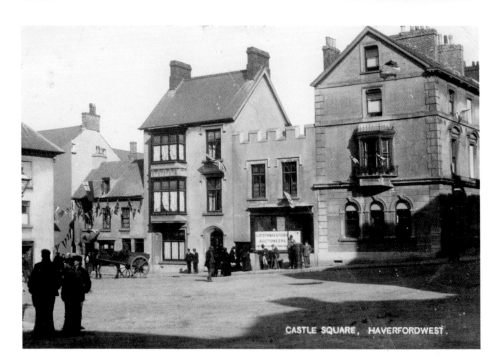

CASTLE SQUARE, HAVERFORDWEST.

Castle Square

The east side of Castle Square was one of the first locations in the town to suffer incongruous redevelopment in the mid-twentieth century. The corner property was originally occupied by the Brecon Old Bank, but following a merger they joined Lloyds Bank, which is still situated on the other side of Victoria Place. The auctioneer's office and Baggott's barber shop were replaced by the rather dismal concrete buildings now in place. The façade of the Friars Vaults is almost unchanged. The open area of the square has undergone a few 'makeovers' since it was pedestrianised. Its central location attracts significant night-time activity.

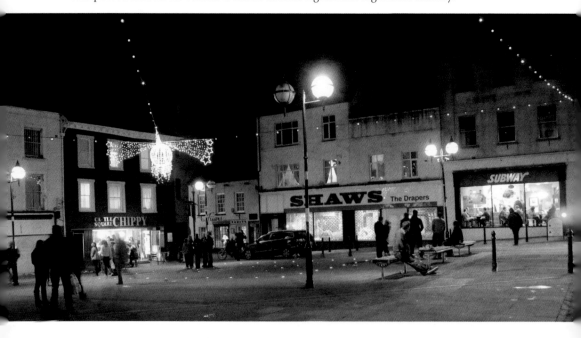

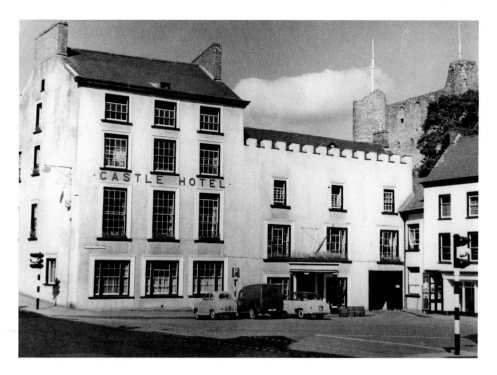

Castle Hotel

The earlier photograph shows the Castle Hotel as it was in the 1950s. It has provided hospitality in the town centre for some three centuries, but not long after this photograph was taken the lower half of the building, with its attractive porch and castellation, was demolished and replaced by a large Woolworths shop. An archway was constructed to allow public access to the castle. Traffic signals can be seen in both pictures; for many years they were the only traffic lights in the town, if not the county!

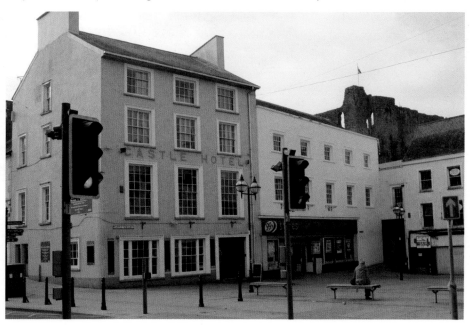

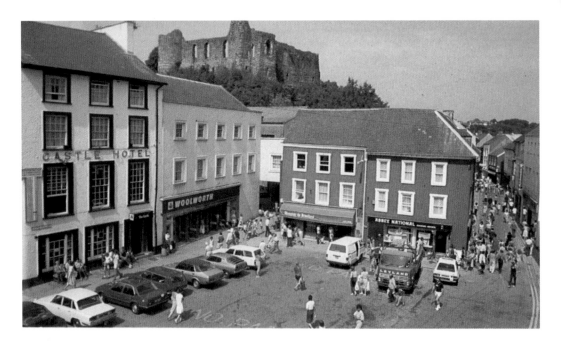

Castle Square

The Woolworths store arrived in town in 1926, acquiring premises in Bridge Street. They moved to a new store in Castle Square in the late 1950s, building their modern shop on the site of the Castle Hotel. Over half a century later the company was a victim of the recession and the shop closed at the end of 2008.

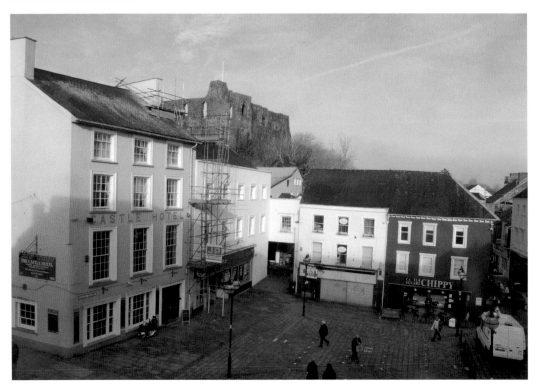

Bridge Street

At first glance little seems to have changed over the years in Bridge Street, apart from it being pedestrianised in the 1980s. In fact, very few of the buildings have survived redevelopment or replacement during the twentieth century. The property now occupied by the Friars Vaults public house was previously an off-licence selling wines and spirits. In 1904 Males bakery shop and refreshment rooms occupied the first premises on the left. Currently it is a gold and pawnshop.

Bridge Street.

The photograph of the Swan Square end of Bridge Street dates from the early 1960s. In 1981 Preseli District Council announced its plan to build a new market hall on the riverside behind this area of Bridge Street. In addition the large premises occupied by Harries the chemist, with its traditional chemist shop frontage, was to be demolished and new shop units built. These can be seen in the present-day photograph. The council's decision to focus on this area of the town was to initiate the repositioning of the town's historic shopping centre to the riverside.

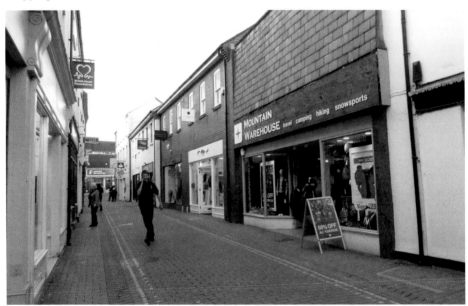

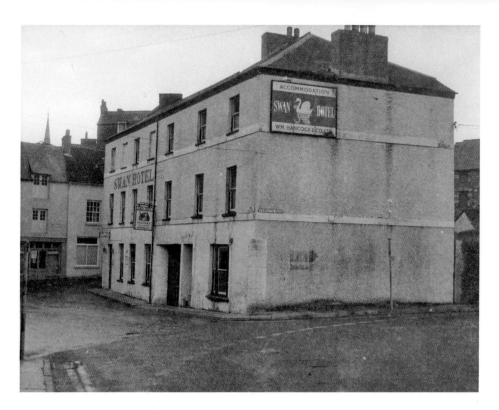

Swan Hotel

Long considered one of the most serious casualties of the ruthless demolition of important buildings in the town, the Swan Hotel, which disappeared in 1968, was one of the oldest inns in a significant area of the town. It was replaced by an ugly black building built for Lipton's grocers. The properties on the corner of Holloway are quite unchanged.

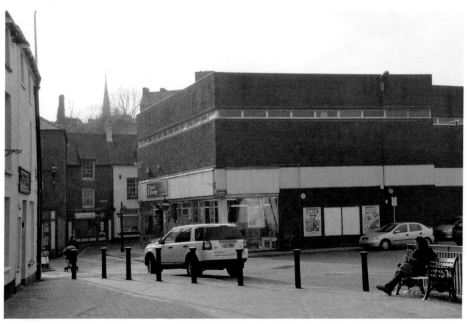

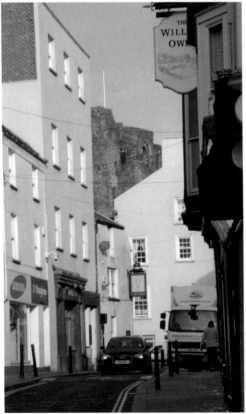

Quay Street

The tall, old warehouse was integrated into the court complex of the Shire Hall providing a vehicular access and garage for custody vehicles. On the departure of the courts to their new location in Hawthorn Rise and the consequent sale of the Shire Hall a shop premises emerged at street level. On the right side of the photograph the sign of the William Owen public house, which opened in 2010 in Wilton House, recalls one of the most important men in the history of the town.

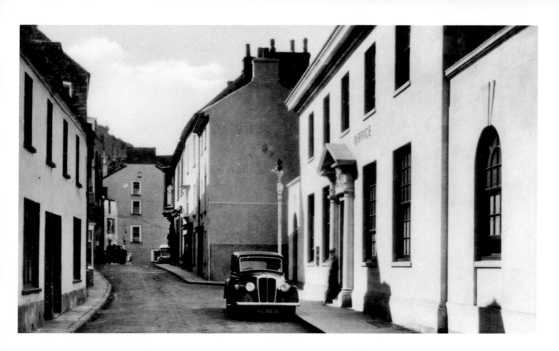

Quay Street Post Office

All the departments of the post office concerned with the Royal Mail moved from the top of High Street to Quay Street in 1936. The new building provided space for the post office counter, sorting office and, at the rear, a loading area for the post vans. The roof was adorned with a cupola mounted by a globe and weathervane. Recently it was announced that the post office is to relocate elsewhere in the town, hence the 'To Let' sign. Quay Street, which remains an important part of the town centre, has recently received a 'facelift' with new wider pavements.

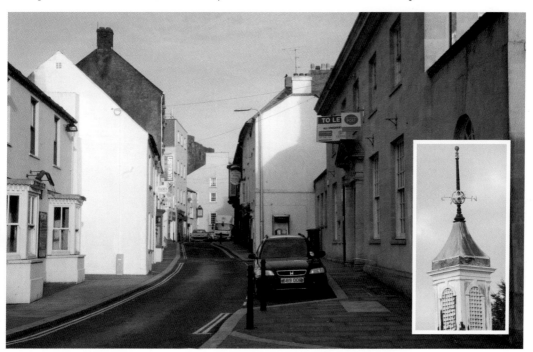

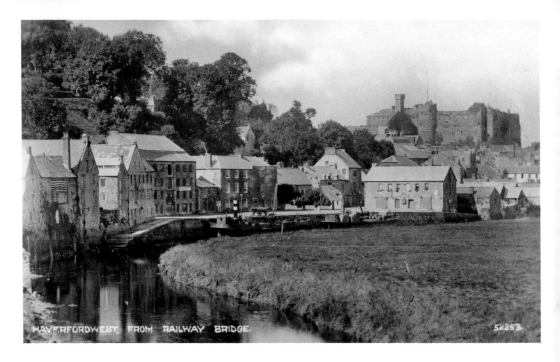

HAVERFORDWEST FROM RAILWAY BRIDGE. 54253

The Quay from the Railway Bridge

The obvious difference between these photographs, taken some 100 years apart, is that motor vehicles have replaced ships, reflecting the change in methods of transport over these years. Considering that the quay's demise as a trading area began with the railway's arrival over 150 years ago, the outline of the view here has changed very little. Fortunately most of the buildings have taken over new roles and so have survived.

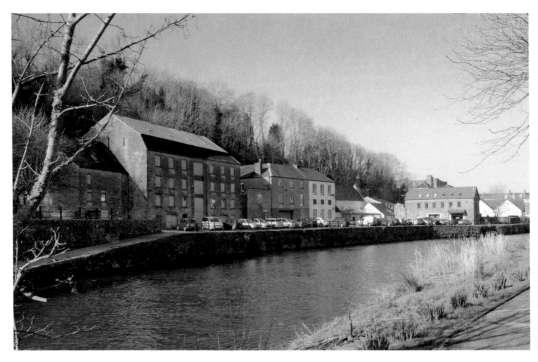

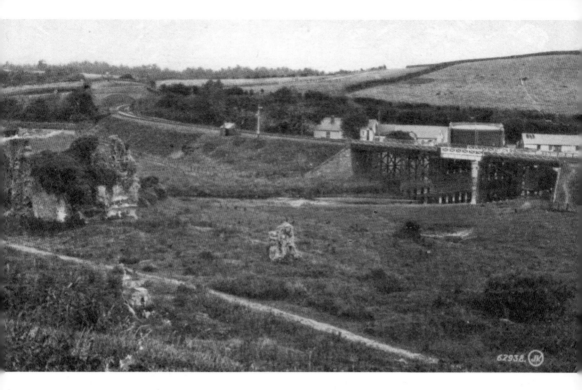

Priory Ruins and Railway Bridge
Founded at the start of the thirteenth century, the Augustinian priory was dismantled following the Dissolution in 1536. In 1983 an extensive excavation project by CADW transformed the ruins, revealing the layout of the church and cloister as well as unique medieval ecclesiastical gardens. Freemens Way now passes alongside the ruins. The fields beyond the gasworks and bridge in the old photograph are now overlaid by the houses of the New Road, Uzmaston Road and Dunsany Park.

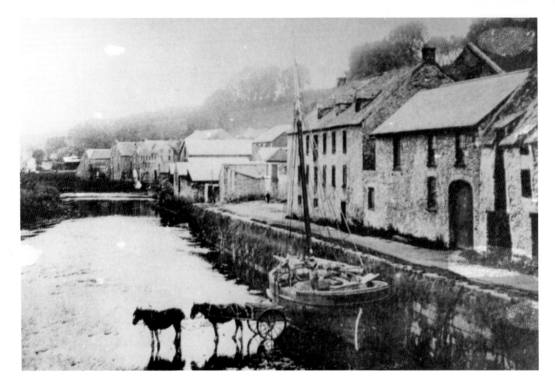

From the New Bridge

The general outline of the quay buildings south of the New Bridge shows little change over the last century, and recalls the days when goods transported by water were loaded and unloaded upriver as far as the Old Bridge. Lime was unloaded at this point and then transported to the kilns in Cartlett Road. A wooden pedestrian bridge installed in 1995 can be seen in the contemporary photograph, and a notice on the riverbank marks the weir, installed in 2003.

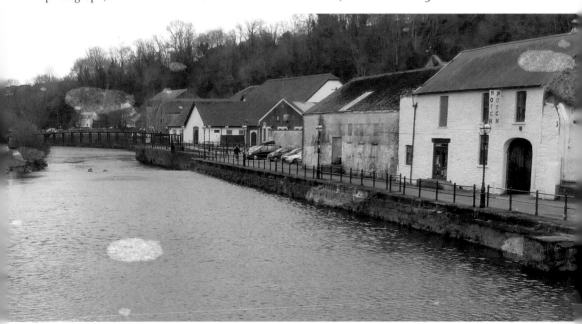

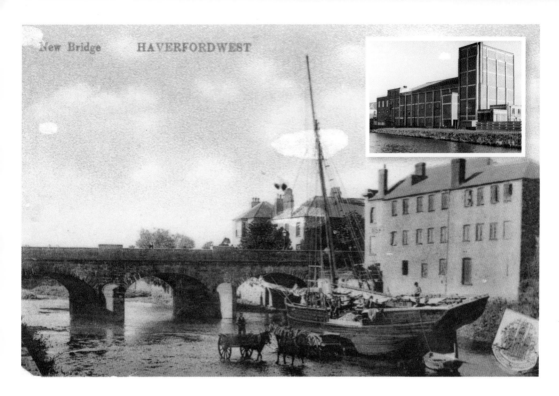

New Bridge HAVERFORDWEST

New Bridge

The building dominating the earlier photograph is Lewis' furniture warehouse. This gave way to the County Theatre, but the site is now occupied by the north wing of County Hall. Beyond the New Bridge is Picton House, which now houses the offices of Haverfordwest Town Council. In the contemporary photograph the roofs of the new Riverside shopping centre can be seen.

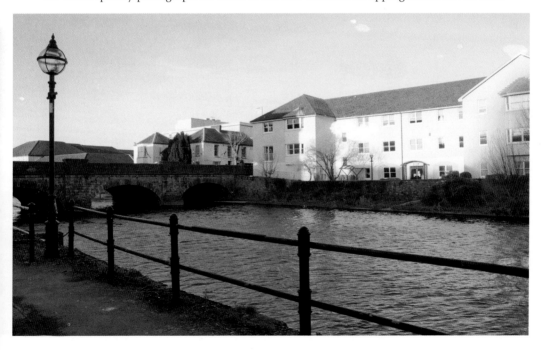

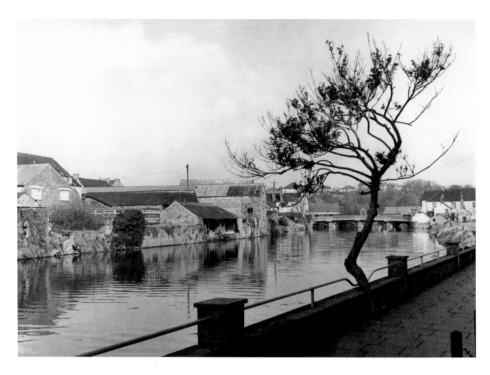

River Cleddau

In the years which have elapsed between these photographs most of the old warehouses and sheds on the Bridge Street side of the river have been demolished and replaced with a market and other retail outlets. These photographs are taken from the opposite bank; the tree for which the railing was specially shaped has long disappeared! Ocky White's temporary building, seen in the older photograph, was replaced by a large extension to the store and an outdoor café area. An ornate pedestrian bridge has been positioned to link the riverbanks.

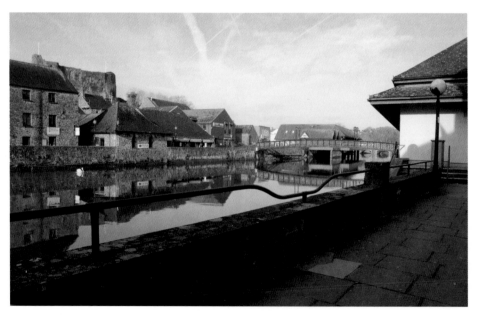

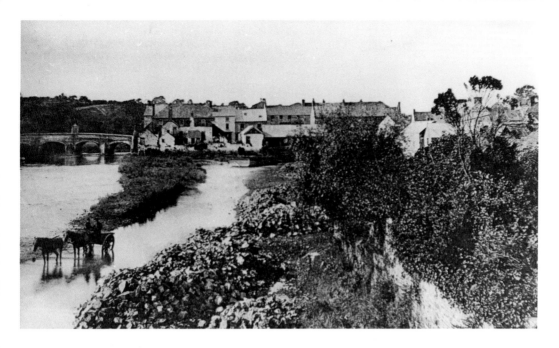

River Cleddau

The only recognisable feature in this picture is the Old Bridge. The photographs show how much of what was the riverside on the east side has been recovered for development. For many years there was a large car park, but the Riverside shopping arcade was then built on the land. The Market Hall, which encroaches onto the riverbed, was built by Preseli District Council and opened in 1982.

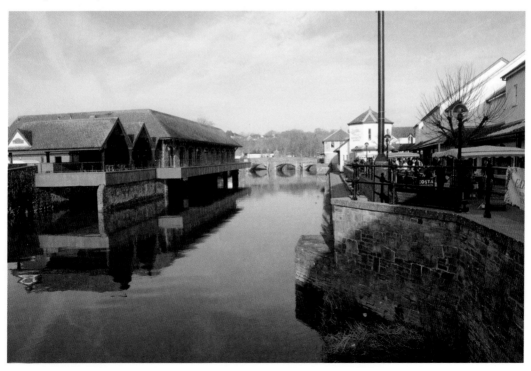

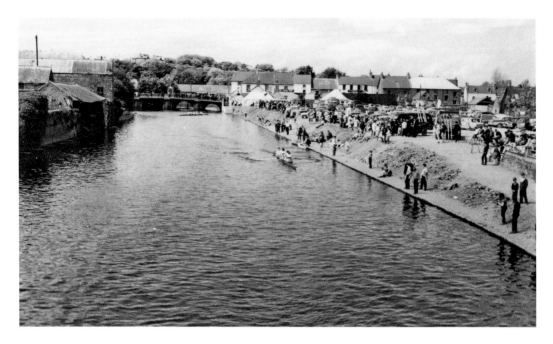

Cleddau Boat Race

This photograph dates from 1967 and records one of the boat races held on the river. The current photograph shows how the Riverside shopping development, which opened in 1990, took over the whole east bank of the river between the old and new bridges.

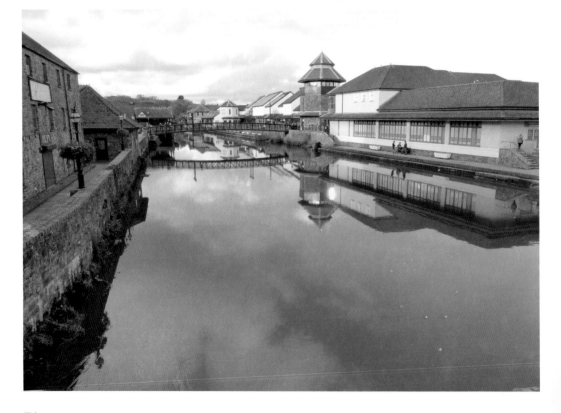

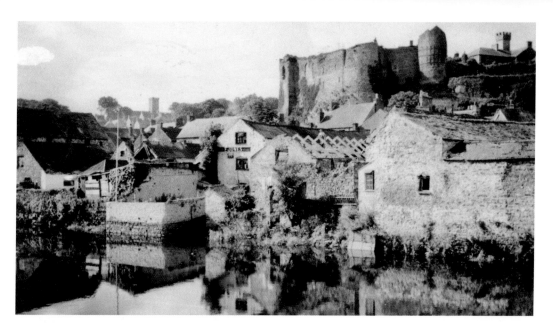

Castle and the Rear of Bridge Street

The old photograph recalls some of the many warehouses and workshops that existed along the riverbank to service the river trade. They have been replaced by the Riverside Market Hall and the connected courtyard of outdoor shops. In the distance County Hall is visible.

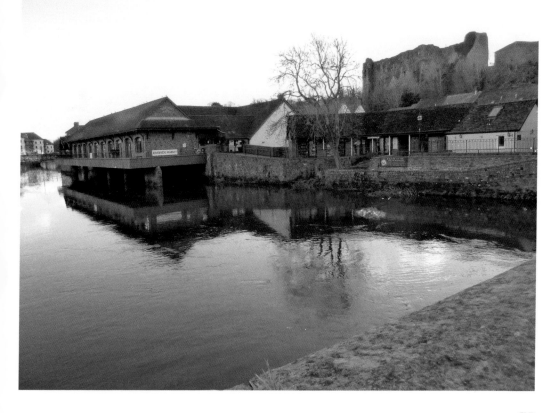

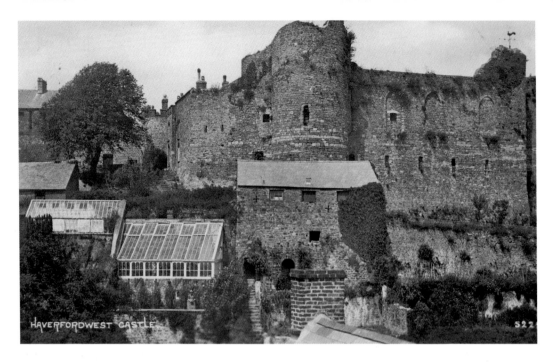

Castle from the Rear of High Street

The castle appears in so many pictures of the town but this is a more unusual view. Until well into the twentieth century properties on the north side of the High Street had long gardens reaching back almost to the castle. The earlier photograph suggests there was a walled garden below the castle at this point. It is now occupied by a picnic and recreation area. The Castle Lake car park was extended to this point when the long corrugated shed behind the old T. P. Hughes shop in High Street was demolished.

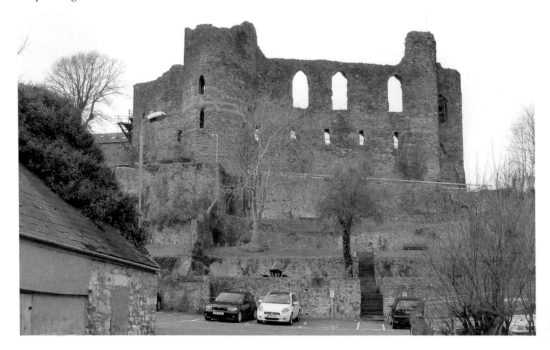

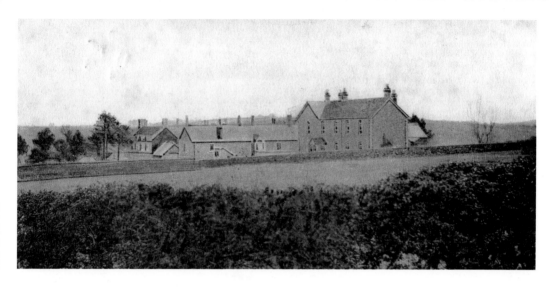

The Union

The Haverfordwest Union Workhouse, designed by local architect William Owen, was built by the Poor Law Union in 1839 on Priory Mount, a site overlooking the ruined priory. Designed to accommodate about 150 inmates, it remained a workhouse until 1948 when it was transferred to the new National Health Service. It was then renamed St Thomas's Hospital, housing a maternity unit and wards for the elderly. For a short time a children's home named Fernlea occupied part of the property. In 1982, following the provision of the new Withybush Hospital, the old workhouse was converted into residential units. It has proved impossible to recreate the original view so the contemporary photograph has been taken from the ruins of the medieval priory on the riverbank.

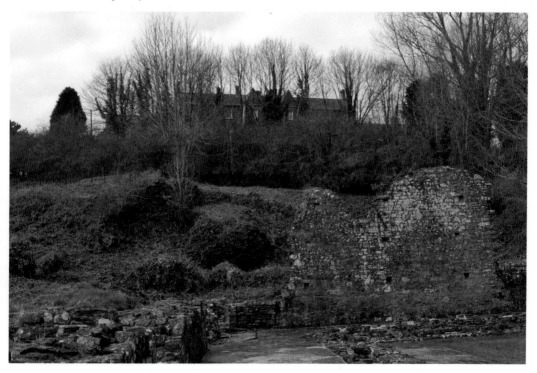

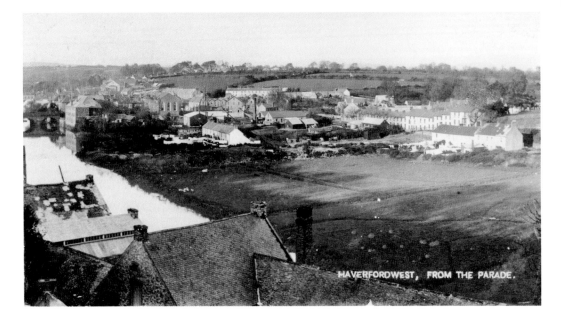

HAVERFORDWEST, FROM THE PARADE.

Haverfordwest from the Parade

It has been impossible to replicate the angle achieved by the early twentieth-century photographer due to almost a century of growth of trees and bushes just below the Parade. The large expanse of land adjacent to Cambrian Place, an almost unchanged terrace of late nineteenth-century houses, was known as the Marsh and accommodated a timber firm and scrapyard. More recently the town's bus station was located in the area. Much of the County Hall complex now occupies the site. The town's first bypass, Freemens Way, was driven through the land adjacent to the Picton playing field, which had been created in the 1930s as a recreation area on what had once been an ash tip.

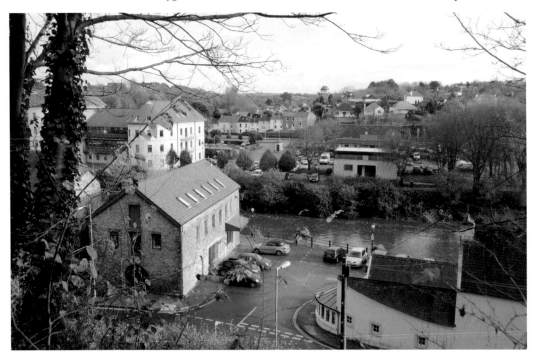

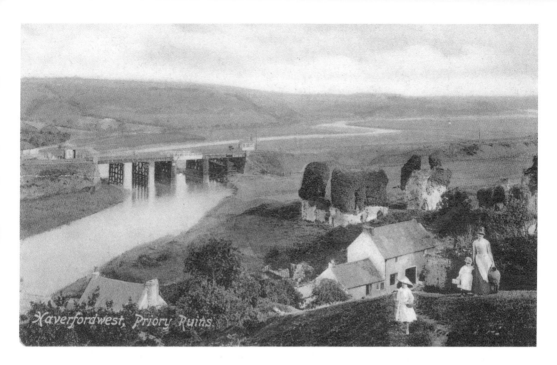

Haverfordwest, Priory Ruins.

The Priory Ruins and Railway Bridge

As is the case with several other views of the town, considerable growth now obscures this scene. Until 1968 the railway bridge could be raised to allow river traffic through to Haverfordwest Quay. A parallel road bridge, part of the Freemens Way bypass, was built in the 1970s. This view of the attractive cottage is taken from the steps linking the Parade and the Union Hill end of Quay Street.

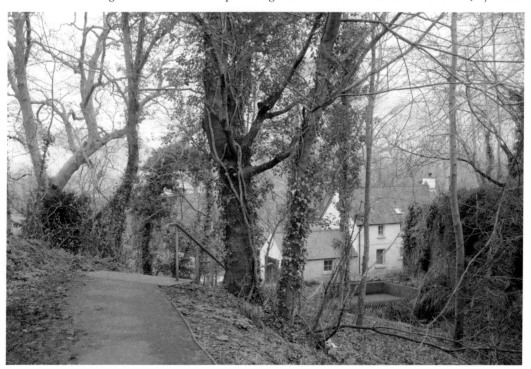

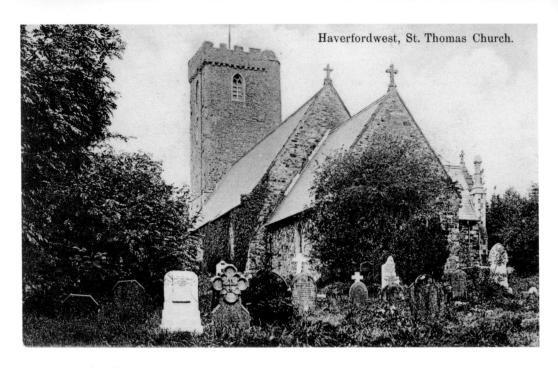

Haverfordwest, St. Thomas Church.

St Thomas Church

Established in the late twelfth century, St Thomas's parish church is renowned for its very large graveyard, the resting place over the centuries of thousands of its parishioners. During the nineteenth century many of them were inmates of the workhouse, asylum and infirmary that were situated in the parish. The fifteenth-century church tower, 75 feet high, is a landmark in the town, clearly visible to the ships sailing up the River Cleddau, and as one of the highest points in the area instrumental in the drawing of OS maps and burning of celebration beacons.

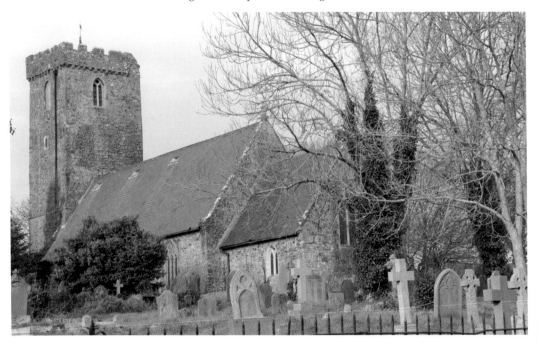

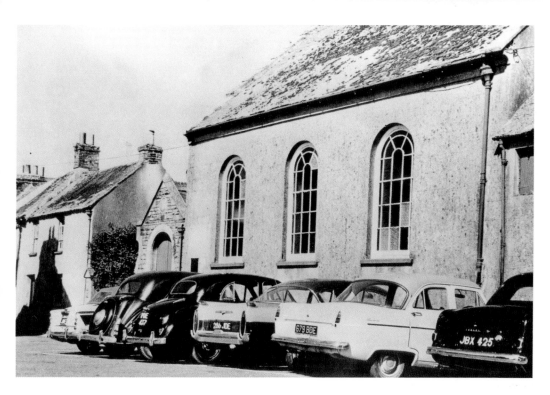

Moravian Chapel

A Moravian Society was formed in the town in the mid-eighteenth century, meeting initially in a warehouse on the Quay. In 1773 they built this chapel, with a burial ground behind, on St Thomas Green. It closed in 1957 and in the 1960s was demolished for the local council to build Moravian Court, a sheltered-housing development.

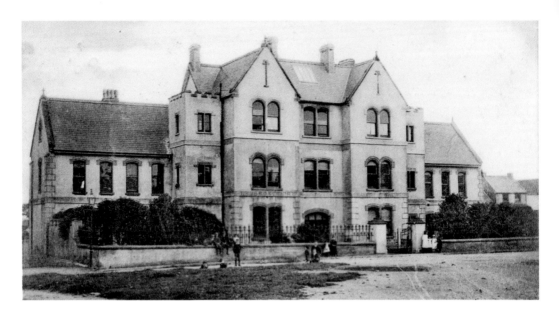

Infirmary

Building of this Pembrokeshire & Haverfordwest Infirmary on the site of an old lunatic asylum on St Thomas Green began in 1872, supported by public subscription. It was enlarged in 1898, but the new County War Memorial Hospital in Winch Lane replaced it in 1923. The building then became the executive centre for Pembrokeshire and became known as the County Offices. Over seventy years later the county administrators moved to the newly built riverside County Hall. The old structure was demolished and the new Pembrokeshire County Council Leisure Centre emerged in 2009.

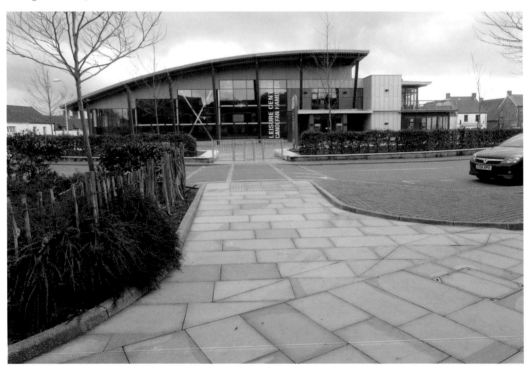

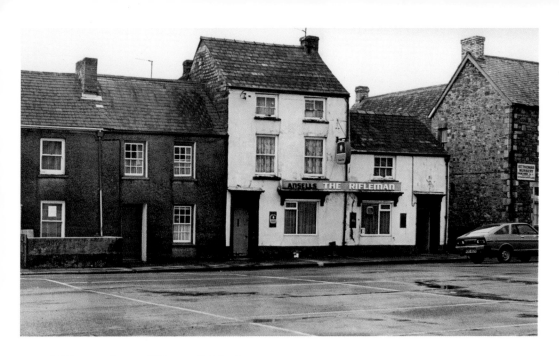

St Thomas Green, Rifleman Public House

The name of the Rifleman public house connects the town's illustrious military history with this inn on St Thomas Green. It survived until 1983, soon after which it was demolished as part of the St Thomas Surgery development. The block of buildings now houses a general store and pharmacy. The name lives on in the Rifleman Field car park at the rear of the building.

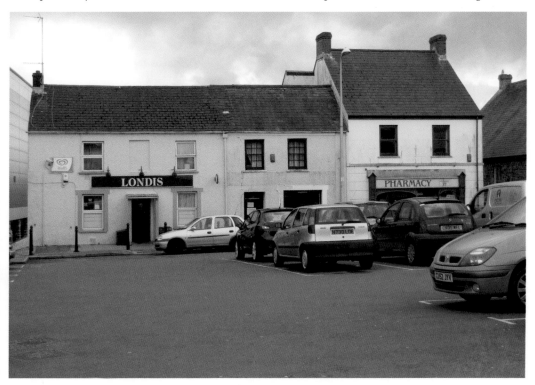

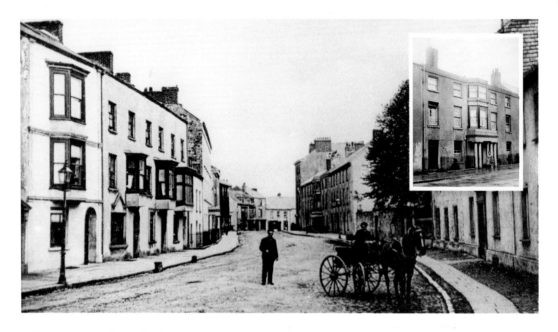

Hill Street, View from St Thomas Green

Hill Street, originally known as King Street, was a very smart area of the town and in 1823 was the first street in the town to be paved. Many of the properties are Georgian, and although cars now rule the road here, the street, the location of the historic Albany chapel, is still one of the most elegant in the town. Hillborough House is a listed building still used a private home. This photograph was taken around 1922 when it was occupied by the family of Vincent Evans, flannel draper. The former Dragon public house, opened in around 1862, was situated next to the Albany chapel and was originally part of the town house home of the Laugharnes of Orlandon. Sir Thomas Picton was born there in 1758.

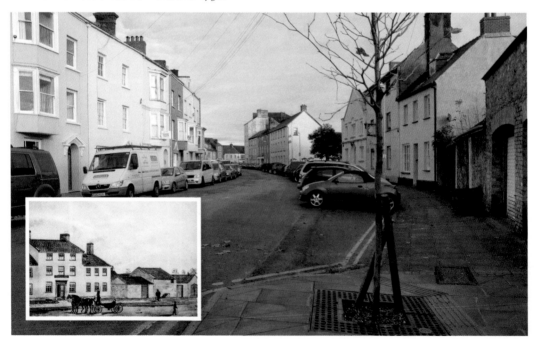

Hill Street, Hill House College

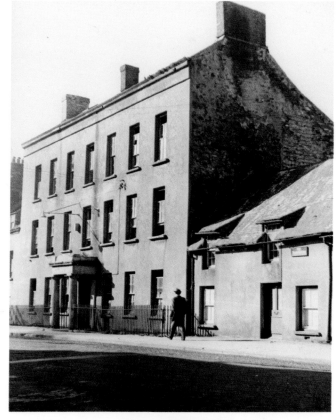

The early photograph shows Hill House College and the Ship (Trafalgar) Inn just before their demolition in 1964. The college is remembered as a school for young ladies run by the Misses Davies, and was housed in an impressive three-storey building, with a porch and double-door entrance. Following demolition College Court, a block of flats, was built by the local council.

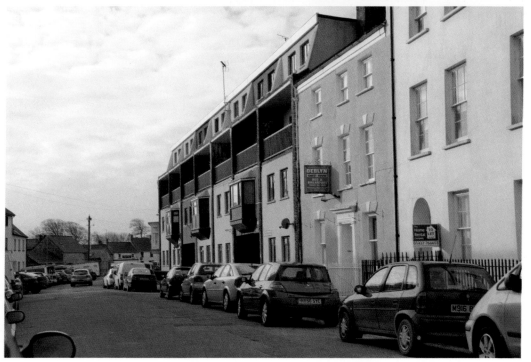

Horsefair

Located on the corner of Scarrowscant Lane and Milford Road, the town's slaughterhouse was built in around 1884 adjacent to the historic site of the town's horse fairs. A lollipop man waits to guide children from the Mary Immaculate School across the usually busy road from Merlin's Bridge. The abattoir was demolished in the 1980s and was replaced by a sheltered housing complex, Hanover Court.

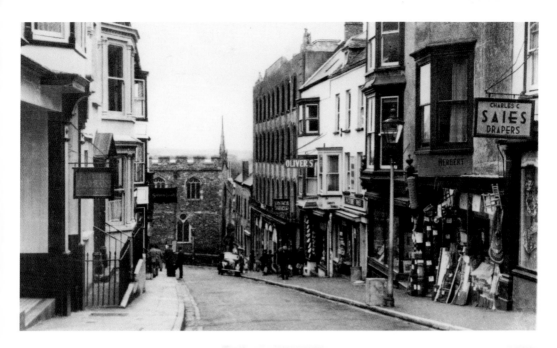

Market Street

The earlier view down Market Street, a busy shopping area, shows the long-established Herbert's ironmongery shop, a legend among those who recall the refusal of the owner to convert to decimalisation. Saies were drapers in the town for many years. At the bottom of the street, on the right, is the china shop on Westaway Corner, demolished in 1952. The new photograph shows the recently rebuilt Commerce House adorned by one of its two statues. The nave of St Mary's church and the spire of St Martin's complete the picture.

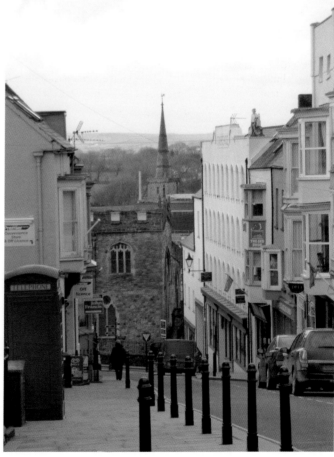

87

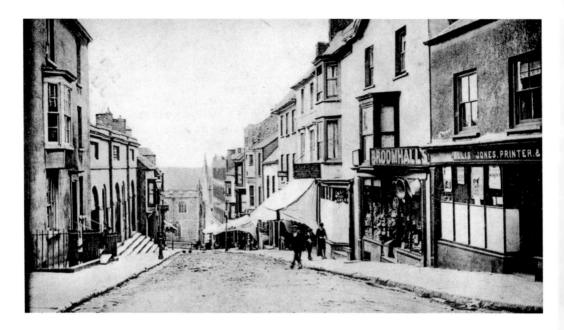

Market Street

The large building with three façades on the left of the older photograph is the town's Market Hall, built by the Town Corporation in 1826. It replaced the open-air market in St Mary's churchyard and the shambles around the Guildhall, and comprised separate sections for a range of different merchandise. In 1895 over forty butchers rented stalls in the marketplace. The façade was replaced when it was reconstructed in the 1930s. The provision of a roof and wooden and concrete floor made it available for a variety of uses such as auctions, dances, political meetings and boxing matches. The market closed in 1982 when the Riverside Market opened behind Bridge Street. The building was later demolished and replaced by a housing development named Shoemakers Court, recalling the original name of Market Street.

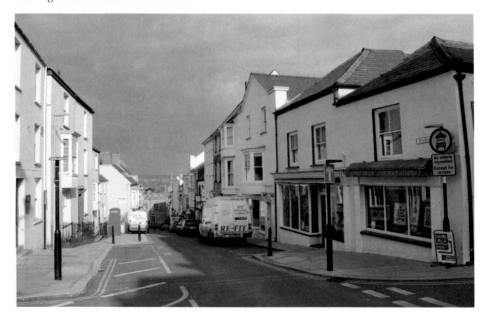

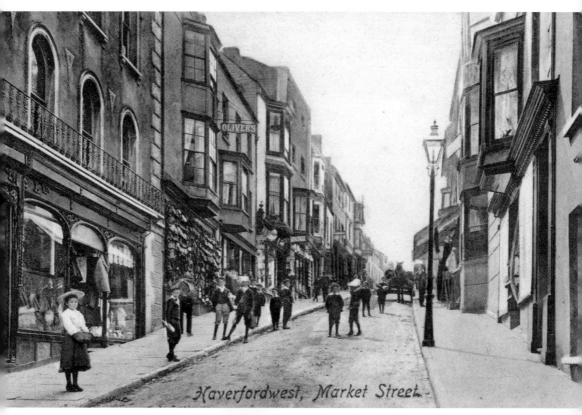

Haverfordwest, Market Street

Market Street

The very large shop adorned with a cast-iron balcony was Commerce House, a major player in the retailing history of the town. Founded by Greenish & Dawkins in the mid-nineteenth century, this emporium sold a vast array of goods and also undertook funerals. In 1871 twenty-seven drapers, dressmakers, milliners and household staff lived in accommodation above the shop. Commerce House closed in 1938, but continued as shop premises. However, the building deteriorated and in 2006 was demolished. In connection with the Haverfordwest Townscape Heritage Initiative scheme it was rebuilt by 2010.

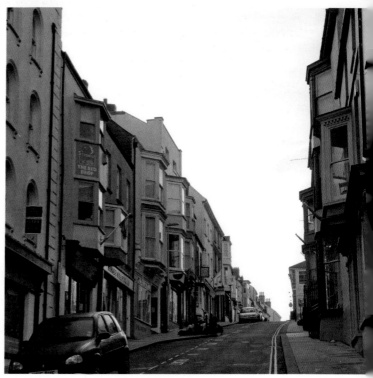

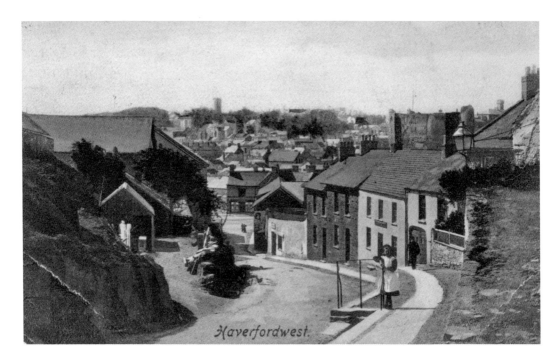

Haverfordwest.

Haverfordwest from Prendergast Hill

The removal of Bland's Garage at the bottom of Prendergast Hill, together with the construction of a multi-storey car park and a large roundabout as part of a new traffic system, has transformed Bridgend Square beyond all recognition. Generally the view of the town remains the same, and the attractive cluster of houses around the tower of St Thomas's church is no longer obscured by trees.

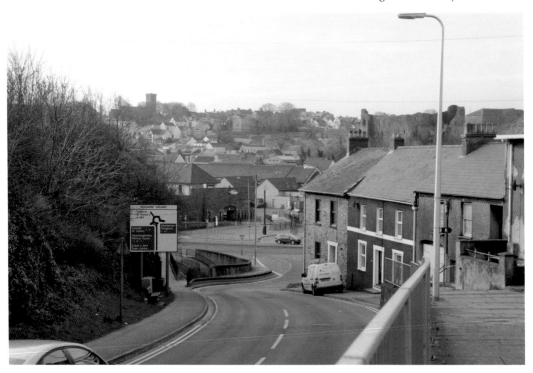

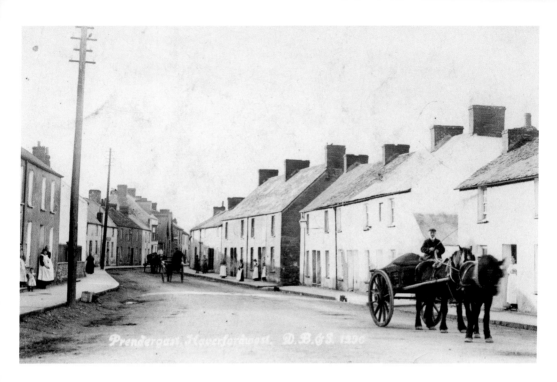

Prendergast

Prendergast has its own parish church and distinctive community. The older photograph shows cottages demolished when Councillor H. J. Rogers built Mayoral Terrace to mark his time as mayor in 1913. On the left side of the road the church hall, built in 1884, survives. The Prendergast relief road, running from the Bridgend Square roundabout to Withybush Hospital, has significantly reduced the volume of traffic travelling up Prendergast Hill.

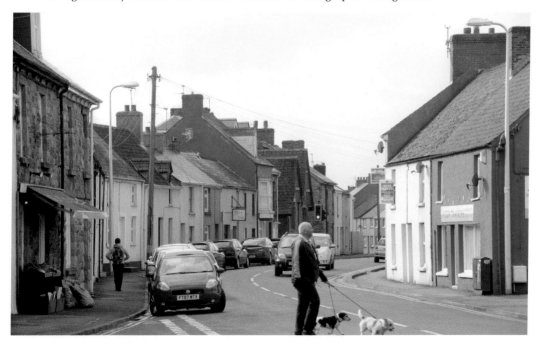

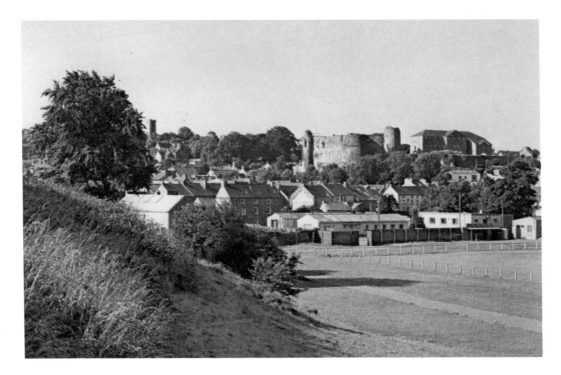

Haverfordwest Castle from Bridge Meadow

The Bridge Meadow was bought with money given to the people of the town solely for recreation purposes by local businessman Sidney Rees just after the First World War. For many years it has been the home of the Haverfordwest County Football Club. In 1993, against much opposition, part of the land was sold for the development of a large supermarket and other retail units. The contemporary photograph shows the repositioned football pitch, new clubhouse and grandstand.

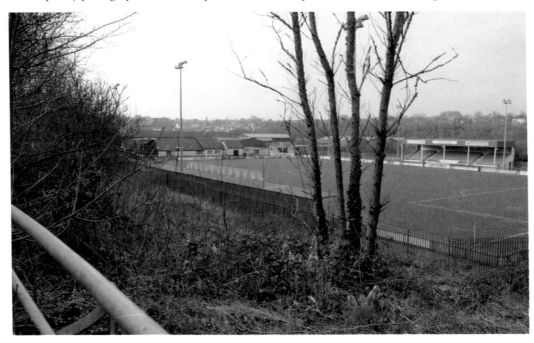

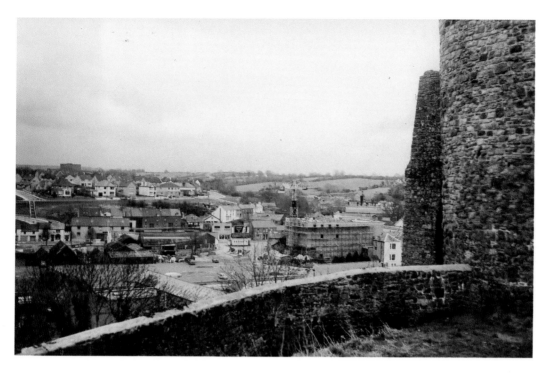

Haverfordwest from the Castle

The earlier photograph was taken in the early 1970s as Tesco was building its first store in the town. Just to its left is the white public weighbridge. The open expanse of the Riverside car park is now occupied by the large shopping centre.

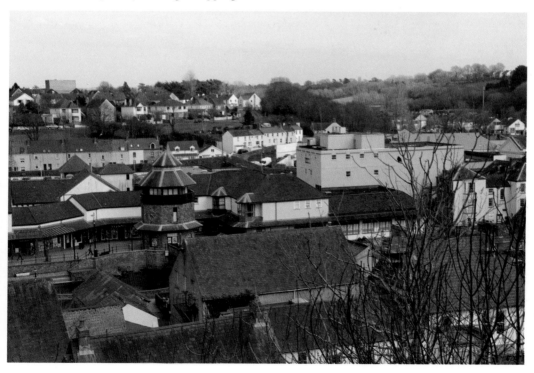

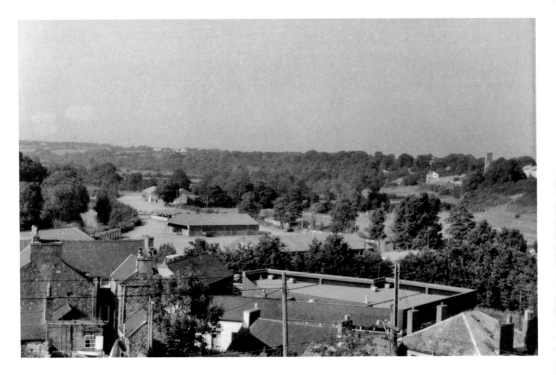

Bridge Meadow from the Castle

This view has changed dramatically over three decades. The mart ground and Bridge Meadow have been replaced by a large supermarket and other retail outlets. The Prendergast relief road now links the town with Withybush General Hospital.

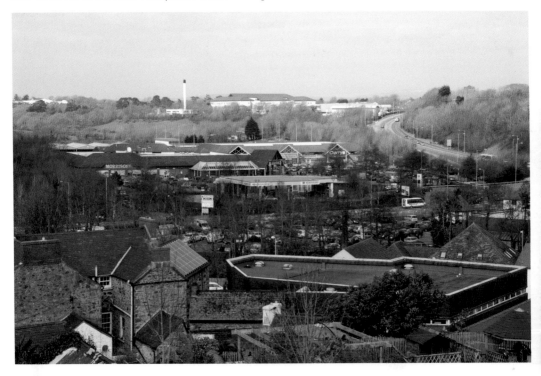

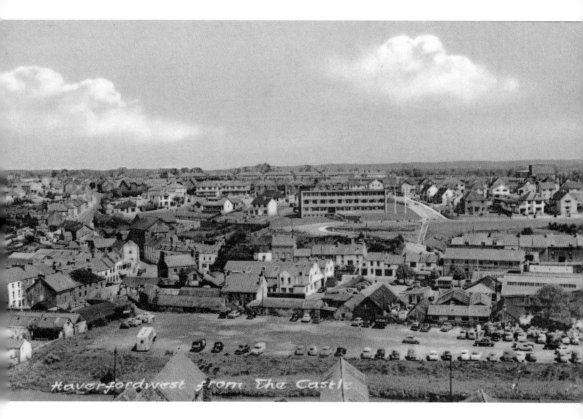

Haverfordwest from the Castle

Haverfordwest from the Castle

Almost the whole of the foreground of the older photograph, from the riverbank to Prospect Place, has been demolished and rebuilt within the last twenty-five years. Beyond that, the large Income Tax Office, built in the 1950s, has now been joined by the new County Records Office building (2013), which has been erected on the former site of the Prendergast Junior and Infant Schools.

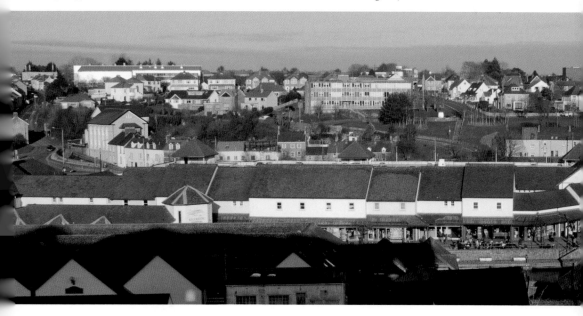